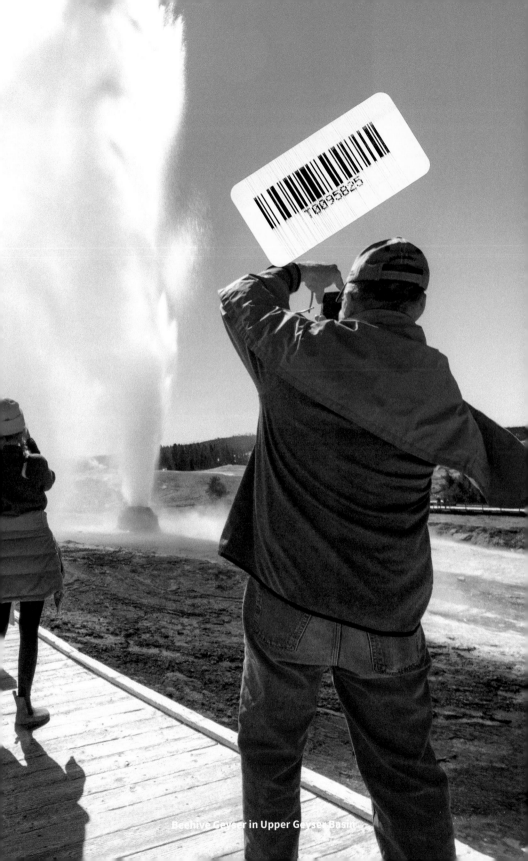

Beehive Geyser in Upper Geyser Basin

THANK YOU for reading PhotoSecrets. As a fellow fan of travelling with a camera, I hope this guide will quickly get you to the best spots so you can take postcard-perfect pictures.

PhotoSecrets shows you all the best sights. Look through, see the classic shots, and use them as a departure point for your own creations. Get ideas for composition and interesting viewpoints. See what piques your interest. Know what to shoot, why it's interesting, where to stand, when to go, and how to get great photos.

Now you can spend less time researching and more time photographing.

The idea for PhotoSecrets came during a trip to Thailand, when I tried to find the exotic beach used in the James Bond movie *The Man with the Golden Gun*. None of the guidebooks I had showed the beach, so I thought a guidebook of postcard photos would be useful. Twenty-plus years later, you have this guide, and I hope you find it useful.

Take lots of photos!

Andrew Hudson

Andrew Hudson started PhotoSecrets in 1995 and has published 25 nationally-distributed color photography books. His first book won the Benjamin Franklin Award for Best First Book and his second won the Grand Prize in the National Self-Published Book Awards.

Andrew has photographed assignments for *Macy's, Men's Health* and *Seventeen*, and was a location scout for *Nikon*. His photos and articles have appeared in *National Geographic Traveler, Alaska Airlines, Shutterbug, Where Magazine*, and *Woman's World*.

Born in England, Andrew has a degree in Computer Engineering from the University of Manchester and was previously a telecom and videoconferencing engineer. Andrew and his wife Jennie live with their two kids and two chocolate Labs in San Diego, California.

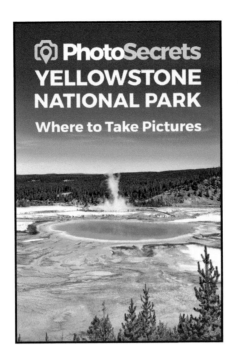

PHOTOSECRETS
YELLOWSTONE NATIONAL PARK

WHERE TO TAKE PICTURES

BY
ANDREW HUDSON

*"A good photograph
is knowing where to stand."*
— Ansel Adams

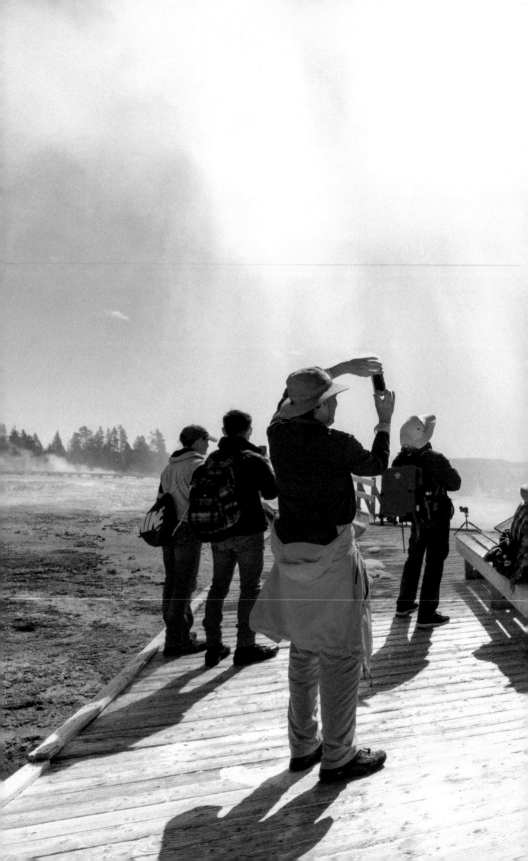

☕ Contents

📷 Gallery

Sunrise

Morning

Afternoon

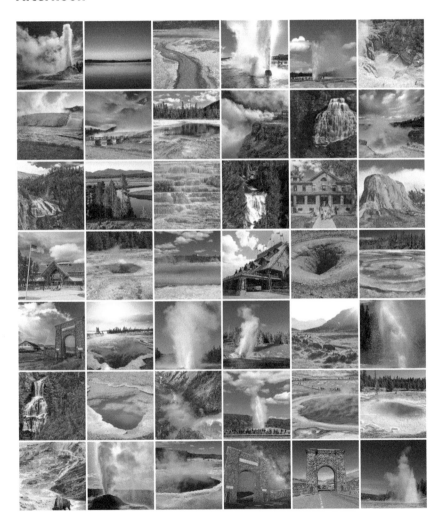

Sunset

Dusk

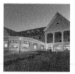

Indoors

◉ Yellowstone National Park

Yellowstone National Park is a land of geothermal wonders, located in northwestern Wyoming. In the center is Yellowstone Lake and most sights are to its northwest, including the most famous feature — Old Faithful.

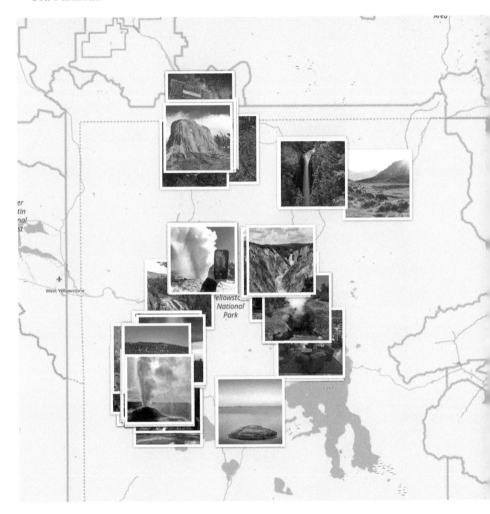

📍 Old Faithful area

Old Faithful is the signature sight of Yellowstone and the first place many people want to photograph. Erupting at predictable times up to 185 feet high, this is a great establishing shot and the start of our photo tour. From here, you can explore the rest of Upper Geyser Basin.

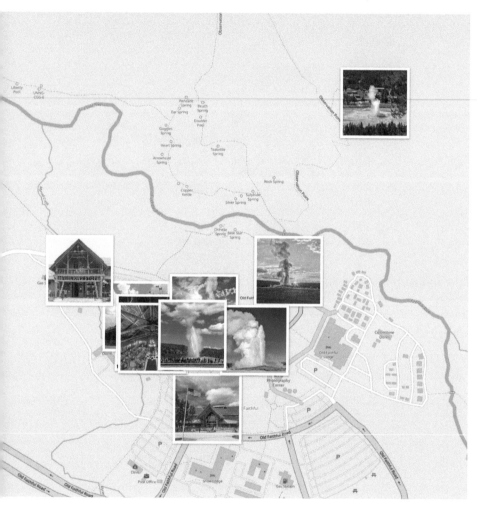

📍 Upper Geyser Basin South

Upper Geyser Basin stretches 1.6 miles (2.6 km) from Old Faithful and contains over 410 geysers, the largest number in the park, and in the world. A flat boardwalk trail leads past colorful pools and towering water spouts, around Geyser Hill and Castle-Grand group in the south.

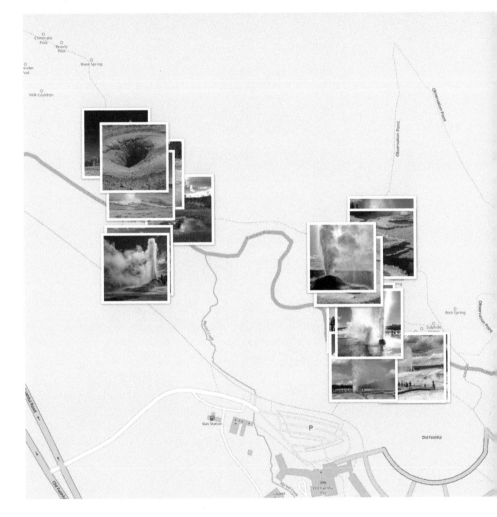

📍 Upper Geyser Basin North

Upper Geyser Basin North is an extended boardwalk north, pas Giant Geyser and Morning Glory Pool. Upper Geyser Basin is on the rim of Yellowstone Caldera, the largest supervolcano on the continent. Further north is Midway Geyser Basin.

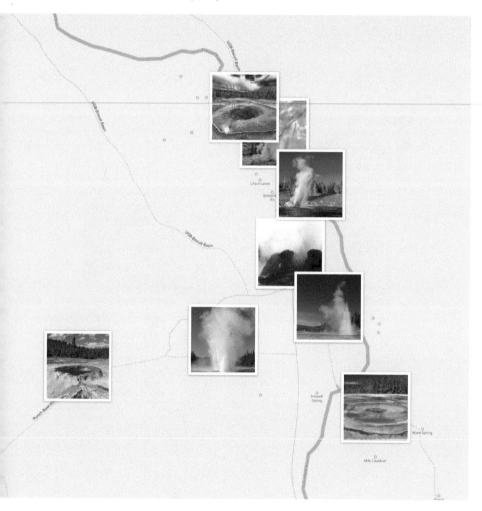

📍 Midway Geyser Basin

Midway Geyser Basin is famous for the colorful Grand Prismatic Spring, the largest hot spring in the park, and the third largest in the world. You can also explore geysers along Firehole River, including Excelsior Geyser Crater.

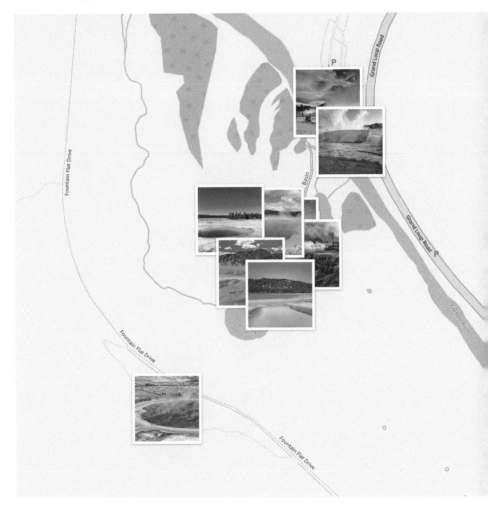

♥ Lower Geyser Basin

Lower Geyser Basin is the second-largest geothermal area in the park, with 283 geysers, but is more spread out. Firehole Lake Drive takes you past the aptly-named Hot Lake and Great Fountain Geyser.

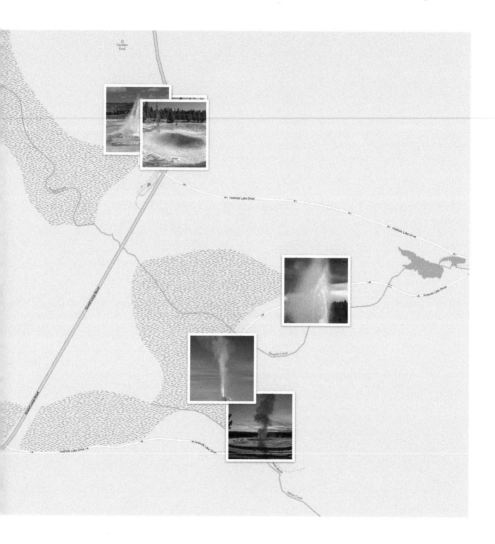

📍 Near Geyser Basin

Near Geyser Basin, along the Firehole River and its tributaries, are scenic waterfalls such as Fairy Falls, Mystic Falls and Kepler Cascades. Smaller geothermal basins include Emerald Pool (in Black Sand Basin) and Lone Star Geyser (in Lone Star Geyser Basin).

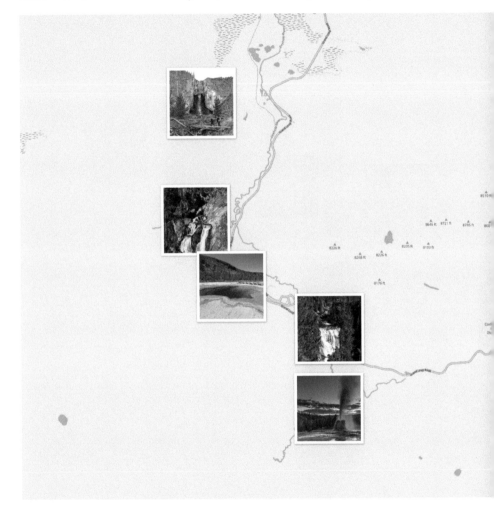

📍 Grand Canyon of the Yellowstone

The **Grand Canyon of the Yellowstone** lies 45 miles (72 km) northeast of Old Faithful and offers stunning photos of the 1,200-foot-deep chasm and the powerful Yellowstone Falls. From Grand Loop Road, you can explores views from the south rim and the north rim.

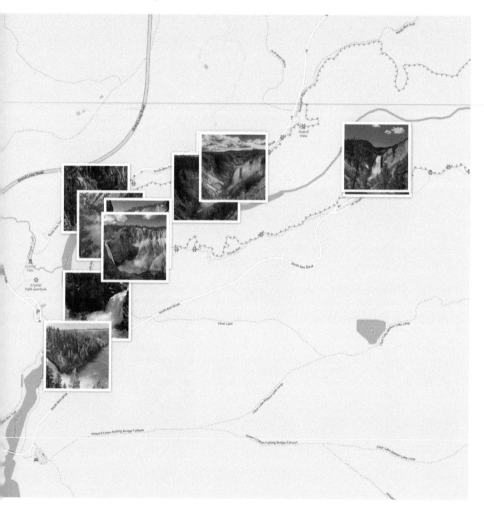

📍 Yellowstone Lake

Yellowstone Lake lies 20 miles south of the Grand Canyon. This is the largest freshwater lake above 7,000 ft (2,100 m) in North America and fills a collapsed part of a caldera of Yellowstone Supervolcano.

♀ Mammoth Hot Springs

Mammoth Hot Springs is a large complex of hot springs on striking travertine terraces. A network of boardwalks takes you past other-worldly landscapes. The area is about 35 miles (56 km) northwest of the Grand Canyon of Yellowstone.

📍 North Park

The **north part of the park** includes Norris Geyser Basin, home to Steamboat Geyser, the world's tallest currently-active geyser. Wildlife photographers will migrate to Lamar Valley and Hayden Valley, to the north of Yellowstone Lake, to find birds, bison and bears.

 Foreword By Bob Krist

A GREAT TRAVEL photograph, like a great news photograph, requires you to be in the right place at the right time to capture that special moment. Professional photographers have a short-hand phrase for this: "F8 and be there."

 There are countless books that can help you with photographic technique, the "F8" portion of that equation. But until now, there's been little help for the other, more critical portion of that equation, the "be there" part.

To find the right spot, you had to expend lots of time and shoe leather to research the area, walk around, track down every potential viewpoint, see what works, and essentially re-invent the wheel.

In my career as a professional travel photographer, well over half my time on location is spent seeking out the good angles. Andrew Hudson's PhotoSecrets does all that legwork for you, so you can spend your time photographing instead of wandering about. It's like having a professional location scout in your camera bag. I wish I had one of these books for every city I photograph on assignment.

PhotoSecrets can help you capture the most beautiful sights with a minimum of hassle and a maximum of enjoyment. So grab your camera, find your favorite PhotoSecrets spots, and "be there!"

Bob Krist has photographed assignments for *National Geographic, National Geographic Traveler, Travel/Holiday, Smithsonian*, and *Islands*. He won "Travel photographer of the Year" from the Society of American Travel Writers in 1994, 2007, and 2008 and today shoots video as a Sony Artisan Of Imagery.

For *National Geographic*, Bob has led round-the-world tours and a traveling lecture series. His book *In Tuscany* with Frances Mayes spent a month on *The New York Times'* bestseller list and his how-to book *Spirit of Place* was hailed by *American Photographer* magazine as "the best book about travel photography."

After training at the American Conservatory Theater, Bob was a theater actor in Europe and a newspaper photographer in his native New Jersey. The parents of three sons, Bob and his wife Peggy live in New Hope, Pennsylvania.

ⓘ Introduction

YELLOWSTONE NATIONAL PARK beckons your camera with towering geysers, colorful geothermal pools, photogenic waterfalls, and abundant Western wildlife.

Located in northwest Wyoming (with 3% of the park in Montana and 1% in Idaho), the park spans 3,468 square miles (8,983 km2) around Yellowstone Caldera, the largest supervolcano on the continent. This active volcano fuels around 10,000 geothermal features — half the world's known number — including hot springs and 1,283 geysers, many of which can be photographed from boardwalk trails.

In the center of the park is Yellowstone Lake, the largest freshwater lake above 7,000 ft (2,100 m) in North America. The water empties through Yellowstone Falls — the largest volume waterfall in the Rocky Mountains — and into the Grand Canyon of the Yellowstone, with its namesake yellow rock (translated to become "Yellow Stone").

The Greater Yellowstone Ecosystem is the largest remaining nearly-intact ecosystem in the Earth's northern temperate zone, home to grizzly bears, wolves, elk, and the largest public bison herd in the United States.

Exploring Yellowstone

The park has five entrances — in the west, east, south, and two in the north — which connect, in the northwest of the park, to a figure-eight route called Grand Loop Road. This 154-mile-long (254 km) parkway takes you to all the major sights. In the center-west of the park, and on the southwest corner of the loop, is Old Faithful. From here you can travel north through Geyser Basin to Mammoth Hot Springs. East of Old Faithful is Yellowstone Lake which leads north through Hayden Valley to the Grand Canyon of the Yellowstone and Lamar Valley.

Although Yellowstone is huge, the main sights are relatively compact and easily explored. Old Faithful and the geyser basins are about seven miles long, the main views along Grand Canyon of Yellowstone are about four miles long, and animals in the valley can be photographed from the Grand Loop Road. Note that most roads are closed by snow so check before traveling in winter.

Photography

Yellowstone National Park was founded, in part, by photography. The large-format photographs of William Henry Jackson from 1871, plus paintings by Thomas Moran and Henry W. Elliott, were integral to Ferdinand Hayden's expedition and report, which led to the park's protection. Hayden warned that "the vandals who are now waiting to enter into this wonder-land, will in a single season despoil, beyond recovery, these remarkable curiosities, which have required all the cunning skill of nature thousands of years to prepare" and advocated preserving "the area as a pleasure ground for the benefit and enjoyment of the people."

Congress concurred and in 1872, President Ulysses S. Grant signed law to create Yellowstone National Park, the first national park in the U.S. and widely held to be the first national park in the world.

When to visit

May/June is probably the best time of year to photograph in Yellowstone. With peak snowmelt, the waterfalls are their strongest, and the cool temperatures draw into view the wildlife and their newborn. Winter is beautiful, with hot geysers bursting against snowy backdrops and geothermal pools covered in steamy clouds, but many roads are closed so access is challenging. Summer has blue skies to emphasize the white geyser spouts and colorful pools, but is crowded so book ahead. Autumn offers fall colors and elk with full-grown antlers.

Planning your day

Timing the sunlight is how professional photographers get those great colors. If you can plan ahead, you can capture your subject literally in the best light. For example, east-facing sights are generally best in the morning and west-facing sights are best in the afternoon.

The peak time for photography is the "golden hour," being the hour after sunrise and the hour before sunset, when the light is golden and casts long shadows for depth. Although it's difficult to arrange, especially with a family and/or a large group, getting out before dawn will give you several hours of amazing photography.

Morning

Early morning is the best time of day to photograph wildlife and the Grand Canyon of the Yellowstone. During the summer, animals are active in the cool temperatures, and people are inactive in their beds, giving you traffic-free roads and the natural world to yourself. Upper and Lower Yellowstone Falls face east, to the rising sun, so the best time to photograph them is in the morning, particularly in the golden hour when the Grand Canyon cliffs burn a deep orange.

Midday

Noon is the best time to photograph the Grand Prismatic Spring and other colorful hot springs. The color comes from bacteria on the bottom of the pool, which receives the most light when the sun is directly overhead.

Afternoon

After spending time to explore the park and find you favorite locations, you can prepare for the last few hours of sunlight. Get into position and keep your camera busy during the Golden Hour (an hour before sunset) and the Blue Hour (dusk, about half an hour after sunset, with cool tones).

Cloudy days

Overcast skies provide even light, which is great for delicate tones such as the faces of people and animals, and the white terraces of Mammoth Hot Springs.

How to photograph geysers

Sunny summer days are best, as the white water stands out most against blue skies, rather than gray/overcast skies. Stand upwind where the spray blows away from you, since the water, and minerals in the water, damages electronics and glass.

If you can, keep the sun to your left or right for the easiest photographs, as this side-lighting will highlight the water. For creative shots, try photographing through the spray into the sun. You may need to adjust the exposure (such as adding +1 or +2 exposure compensation)

to keep the water white rather, otherwise your camera may misread the exposure and make the photo too dark.

The most valuable tip is to have luck, as most geysers erupt erratically and infrequently, so get into an area where you can reach several geysers on quick notice.

Predicting geyser eruptions

Except for Old Faithful, most geysers are difficult to predict. Timing depends on a variety of factors, such as the supply of groundwater, the proximity to magma, the amount and timing of previous eruptions, and the air temperature. Fortunately, the National Park Service posts predicted times. Get the current information at:

- Old Faithful Visitor Education Center
- Online at nps.gov/yell/planyourvisit/geyser-activity.htm
- Twitter: @GeyserNPS
- On the free NPS Yellowstone app

Why geysers?

Yellowstone's volcanic geology provides the three key components: heat, water, and a natural "plumbing" system. Magma beneath the surface provides the heat; rain and snowfall seep deep underground to supply the water; and underground cracks and fissures form the plumbing. Hot water rises through the plumbing to surface as hydrothermal features.

Safety

Natural situations are inherently dangerous. Stay on boardwalks and trails in thermal areas as boiling water surges just under the thin crust of most geyser basins, and many people have been severely burned when they have broken through the fragile surface.

To protect yourself and the animals you come to watch, always remain at least 100 yards (91 meters) from bears or wolves, and at least 25 yards (23 meters) from all other wildlife. It is dangerous and illegal to disturb or displace animals.

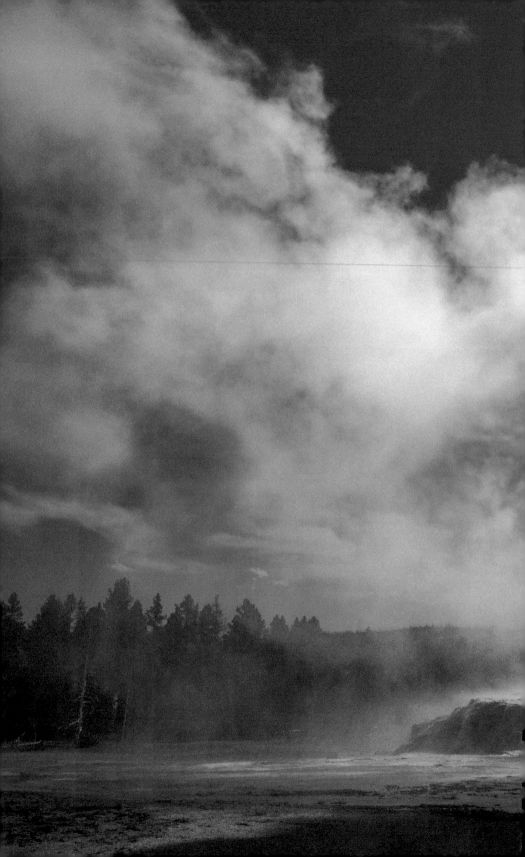

Geyser Basin

Castle Geyser in Upper Geyser Basin

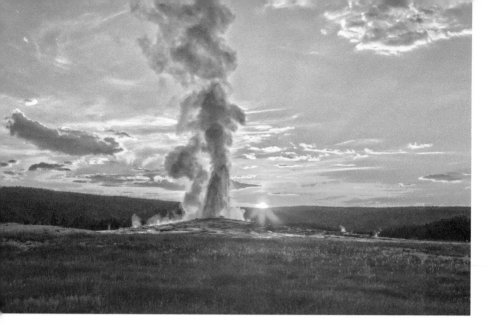

Old Faithful is the world's most famous geyser and always justifies a visit — and photograph. This was the first geyser in the park to receive a name (in 1870), and it remains the park's most popular and predictable geothermal feature.

Current eruptions are 68 or 94 minutes apart (dependent on the length of the prior eruption), and predicted by the National Park Service with +/-10 minute accuracy. The regularity is due to a dedicated supply system, separate from the rest of Upper Geyser Basin.

Old Faithful is easily photographed. There is a circular boardwalk and trail with a radius of about 340 feet (110 m) from the geyser so that, even in the busy summer season, you can get a front-row view. Standing on the concrete path to the southwest allows you to include people (right) for a valuable sense of scale.

✉ **Addr:**	Upper Geyser Basin, Yellowstone NP WY 82190	♀ **Where:**	44.461026 -110.826986
❓ **What:**	Geyser	◔ **When:**	Morning
👁 **Look:**	Southwest	Ⓦ **Wik:**	Old_Faithful

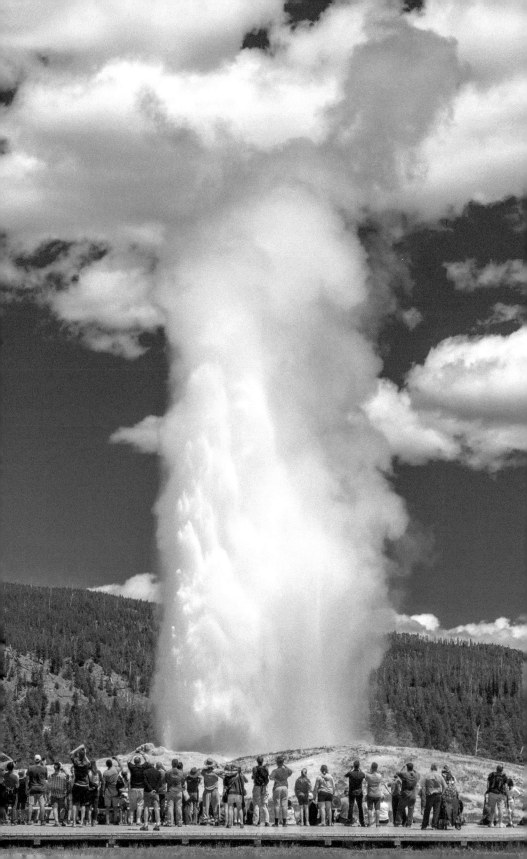

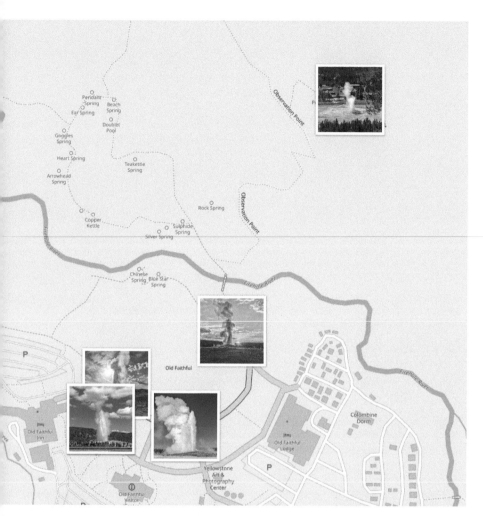

Peridant Spring
Beach Spring
Ear Spring
Doublet Pool
Goggles Spring
Heart Spring
Teakettle Spring
Arrowhead Spring
Rock Spring
Copper Kettle
Sulphide Spring
Silver Spring
Chinese Spring
Blue Star Spring

Observation Point

Firehole River

Old Faithful

P

Old Faithful Inn

Colombine Dorm

Old Faithful Lodge

P

Yellowstone Art & Photography Center

Old Faithful Visitor

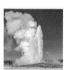
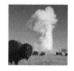

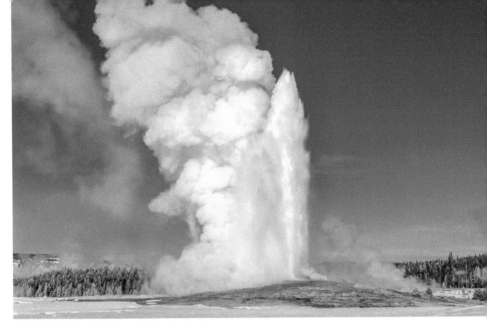

Views from the main viewing board to the south (above) and southwest (below left).

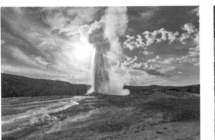 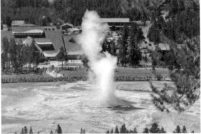

Observation Point (above-right) offers a high view after a 2/3-mile (1 km) hike.

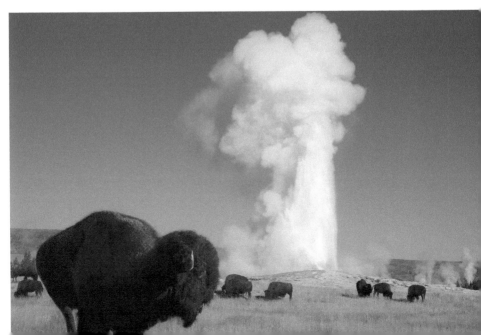

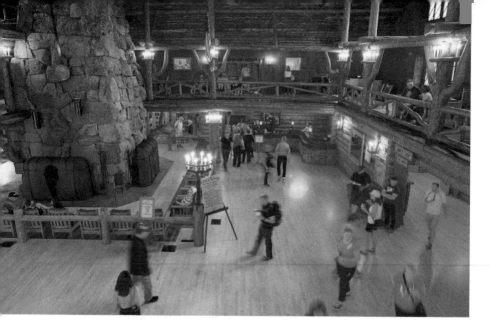

Old Faithful Inn is a landmark hotel just 800 feet (250 m) west of the Old Faithful Geyser. Built from logs cut about eight miles (13 km) south of Old Faithful, this is the largest log hotel (and possibly log building) in the world. Designed by Robert Reamer in a rustic Adirondacks style, the Inn opened in 1904 as the first great park lodge of the American west.

The seven-story lobby is a marvel to behold, made entirely of logs and tree limbs. In the southeast corner is a massive, 500-ton stone fireplace, 16 feet (4.9 m) square at the base, with hearths on each face and corner. The stone extends 85-feet high, into the gabled roof.

Photograph from the second-floor balcony with a wide-angle lens. Including people and the fireplaces gives scale and dimension to your shot.

✉ **Addr:**	3200 Old Faithful Inn Rd, Yellowstone NP WY 82190	♀ **Where:**	44.459725 -110.831154
❷ **What:**	Hotel	◷ **When:**	Morning
👁 **Look:**	Southwest	W **Wik:**	Old_Faithful_Inn

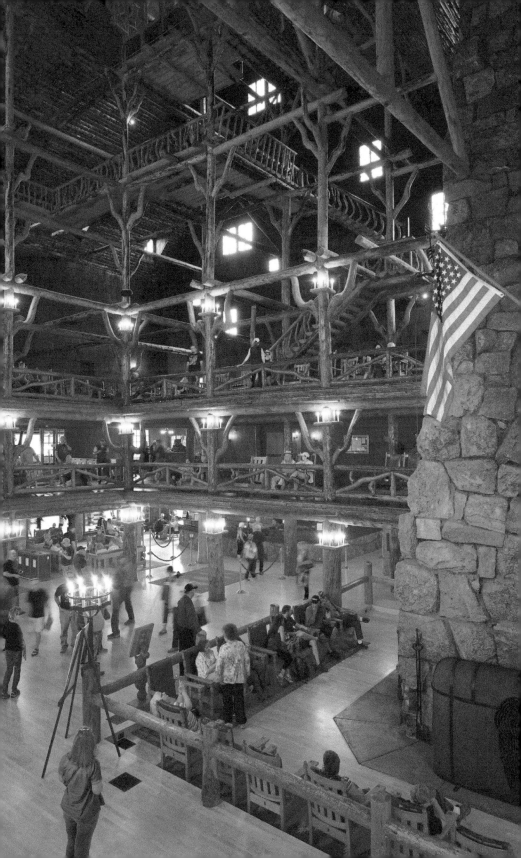

Old Faithful
Inn Dining
Room

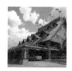

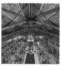

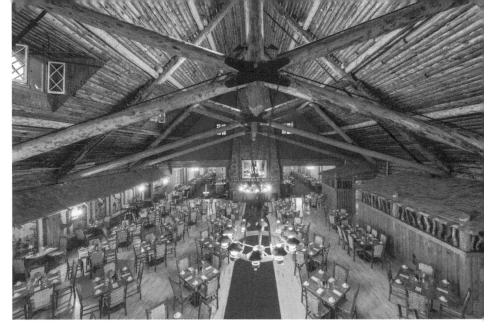

Above: The dining room has log scissors trusses, photographed from the balcony.

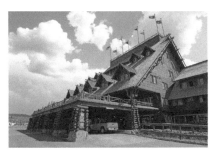

Below: Stairs climb to the "Crow's Nest," where musicians used to entertain guests.

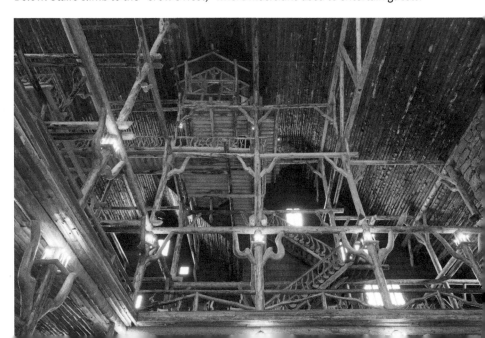

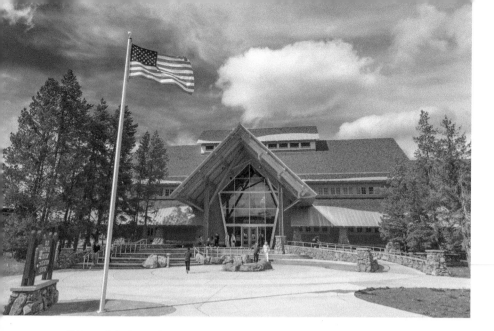

Old Faithful Visitor Education Center is the largest visitor
center in the park and your resource for all things Yellowstone.
Located about 1,200 feet (400 m) southwest of Old Faithful, the building
features a 60-foot-tall (18 m) viewing window.

Opened in 2010, the center includes hands-on exhibits, a theater, and the Yellowstone Association Bookstore.

This view is from the south entrance, by the parking lot. Including the flagpole adds a foreground, to give your photo depth.

✉ **Addr:**	View Avenue, Yellowstone NP WY 82190	📍 **Where:**	44.458078 -110.82945
❓ **What:**	Visitor center	🕐 **When:**	Afternoon
👁 **Look:**	North-northeast	↔ **Far:**	60 m (190 feet)

Hamilton's Store

is an historic concession with rustic log and twig decoration.

In 1905, Winnipeg native Charles Hamilton arrived in Yellowstone aged 21, to work in the park. Befriending the son of the Yellowstone Park Company's president, Hamilton was able to buy this general store in 1915. He enlarged the building and added an elaborate burled log porch in 1925.

Hamilton's Stores was the main park concessionaire from 1953 to 2002, when the National Park Service awarded the contract to Delaware North.

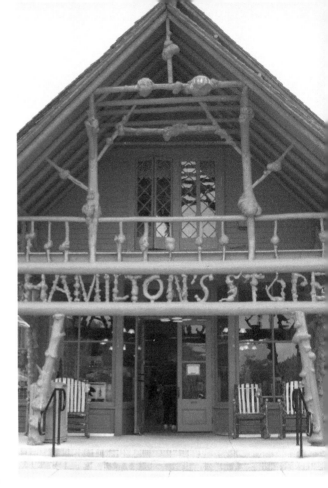

✉ **Addr:**	1 Old Faithful Rd, Yellowstone NP WY 82190	♀ **Where:**	44.461014 -110.833452	
❷ **What:**	Store	◑ **When:**	Morning	
👁 **Look:**	South-southwest	W **Wik:**	Hamilton%27s_Stores_(Yellowstone_National_Park)	

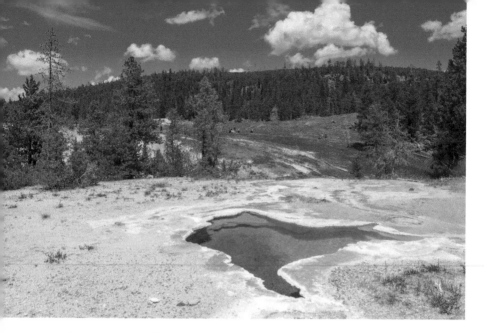

Blue Star Spring is the nearest photograph-worthy feature to Old Faithful. Located on the circular boardwalk trail, on the north side by Firehole River, the spring is a picturesque turquoise color. An edge of calcium carbonate deposit — called "sinter" — gives the spring a star-like shape.

Like all geothermal pools, Blue Star Spring is best photographed on a blue-sky day around noon, when the sun is directly overhead. This maximizes the light (and color) in the pool, and minimizes the glare.

From near here, you can photograph erupting Beehive Geyser, across the river to the northwest, on Geyser Hill.

✉ **Addr:**	Old Faithful Group, Yellowstone NP WY 82190	♀ **Where:**	44.461857 -110.8286
❓ **What:**	Geothermal pool	☽ **When:**	Morning
👁 **Look:**	North	↔ **Far:**	7 m (23 feet)

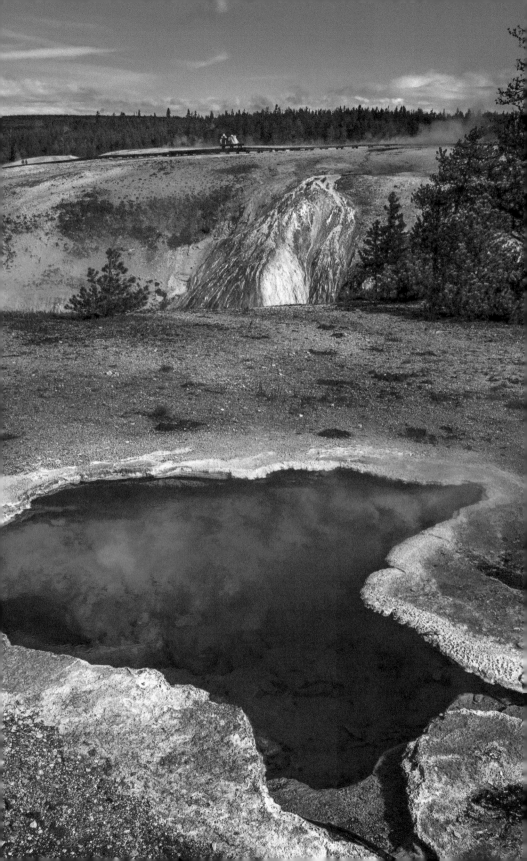

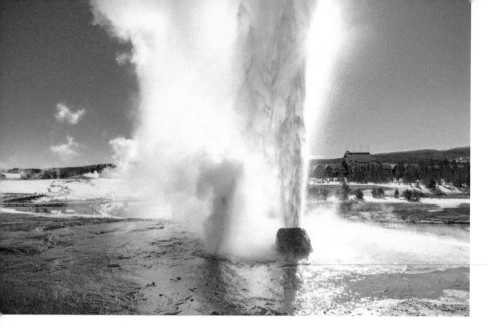

Geyser Hill is a one-mile (1.6 km) circle boardwalk just north of Old faithful. The first photographic sight is **Beehive Geyser** with several vantage points, including the boardwalk on the north side of Old Faithful by Blue Star Spring. These photos are shot into the sun, to illuminate the water.

 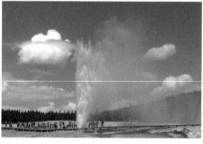

✉ **Addr:**	Geyser Hill, Yellowstone NP WY 82190	♀ **Where:**	44.462728 -110.82996
❷ **What:**	Geyser	◐ **When:**	Morning
👁 **Look:**	South-southwest	W **Wik:**	Beehive_Geyser

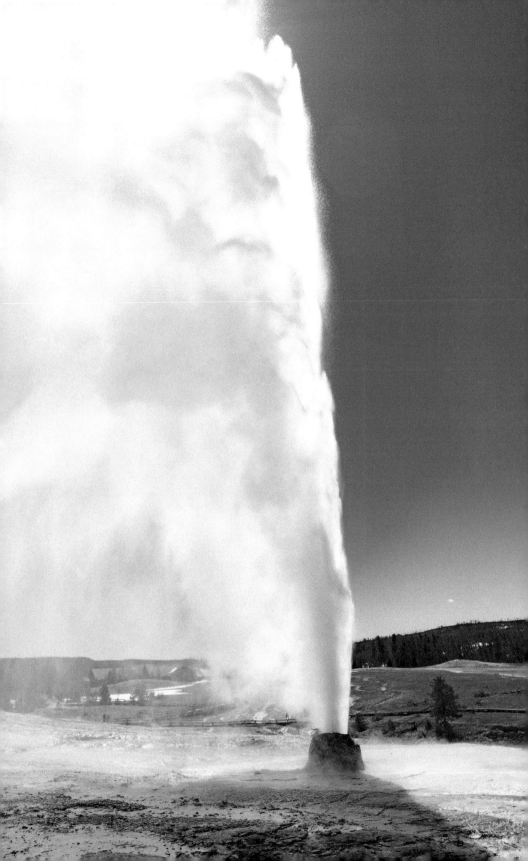

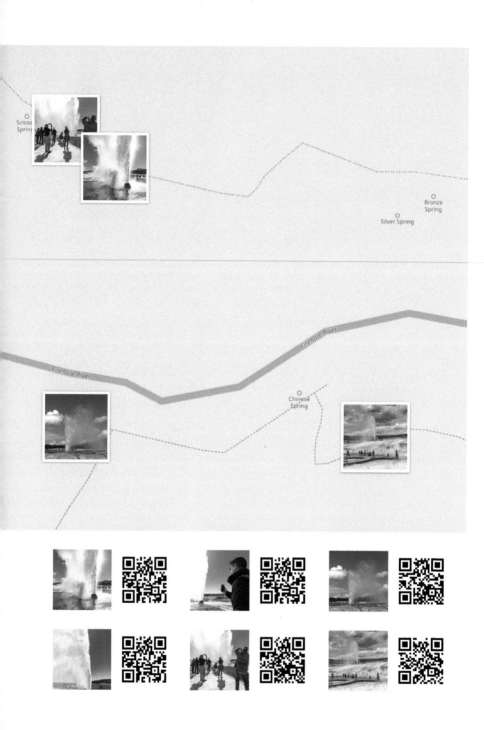

Scissor
Spring

Bronze
Spring

Silver Spring

Firehole River

Firehole River

Chinese
Spring

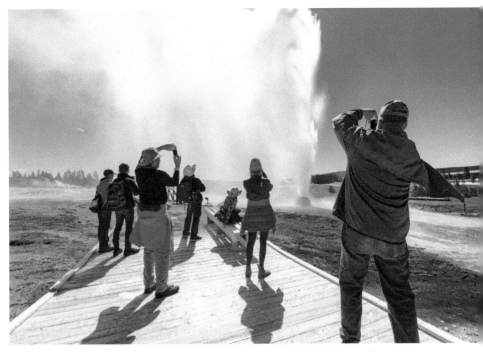

Include people as your foreground to capture the excitement of the eruption. With travel photography, you are often faced with a distant subject, so always seek a good foreground, such as flowers or people, to give your image depth and life.

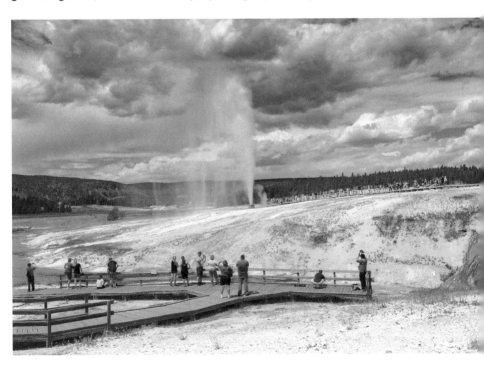

Heart Spring and Lion Geyser are features on the west side of Geyser Hill, after Beehive Geyser when walking clockwise on the loop. Heart Spring is 15 feet deep and provides foreground and contrast to the roaring, 90-foot-high (27 m) Lion Geyser.

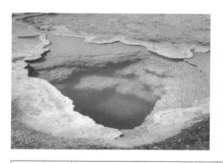 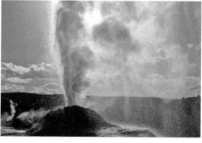

✉ **Addr:**	Upper Geyser Basin, Yellowstone NP WY 82190	♀ **Where:**	44.463773 -110.830563
❷ **What:**	Geyser	☽ **When:**	Morning
👁 **Look:**	Northwest	W **Wik:**	Lion_Geyser

Goggles
Spring

O
Heart S

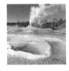

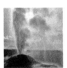

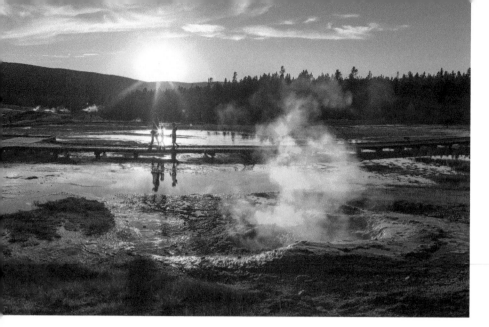

Aurum Geyser and Doublet Pool

Aurum Geyser and Doublet Pool in the northeast of Geyser Hill is another two-for-one shot. Doublet Pool has a scalloped edge made of geyserite, a form of opaline silica, which you can focus on with a "detail" shot. By zooming in and cropping out the edge, you can create an abstract image.

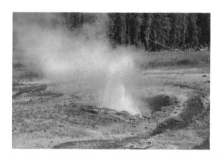
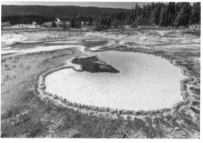

✉ **Addr:**	Upper Geyser Basin, Yellowstone NP WY 82190	♀ **Where:**	44.4643332 -110.8295784	
❓ **What:**	Geyser	⏲ **When:**	Morning	
👁 **Look:**	West	W **Wik:**	Doublet_Pool	

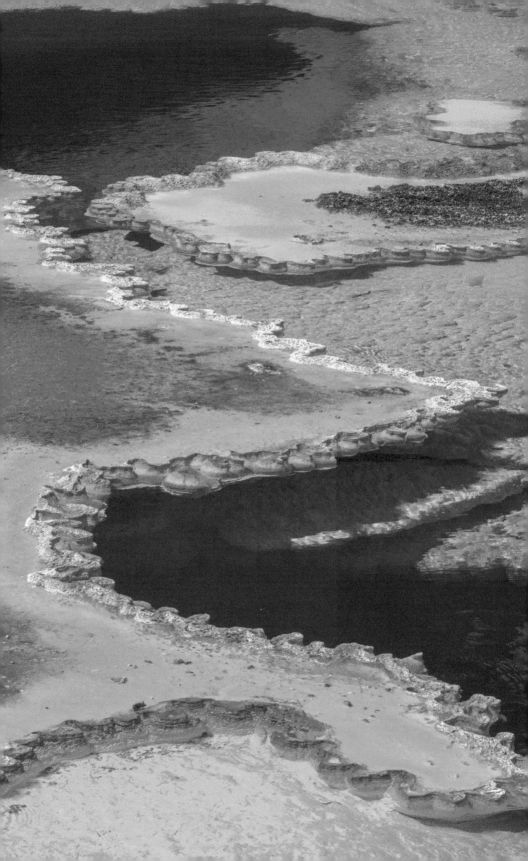

Beach Spring

Doublet Pool

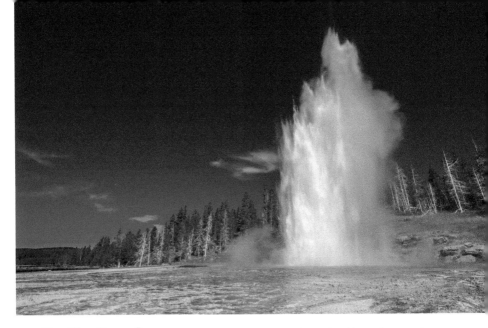

The **Castle-Grand** group is an extended loop boardwalk to the north of Geyser Hill. Along this extra 1.2 mile (2 km) flat trail, you can visit Grand Geyser (above), Spasmodic Geyser (below-left), Liberty Pool (below-right) and more.

✉ **Addr:**	Upper Geyser Basin, Yellowstone NP WY 82190	♀ **Where:**	44.46387 -110.836674
❷ **What:**	Geyser group	◑ **When:**	Afternoon
👁 **Look:**	Southeast	W **Wik:**	Grand_Geyser

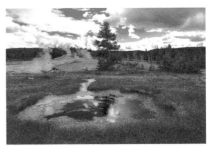

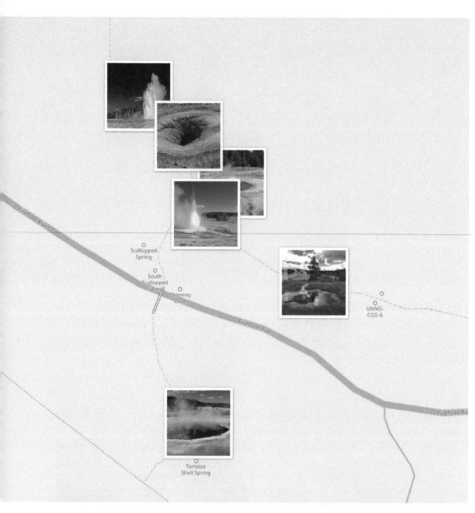

Scallopped
Spring

South
Scallopped
Spring

Chimney
Cone

Firehole River

Firehole River

Firehole River

UNNG-
CGG-6

Tortoise
Shell Spring

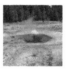

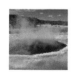

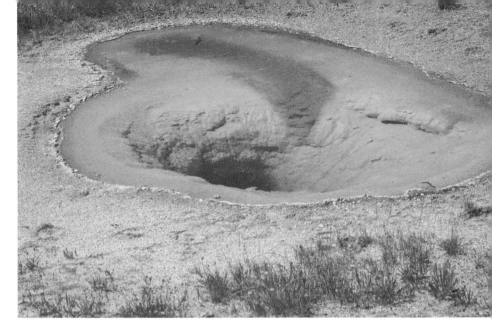

Above and below-left: Belgian Pool looks like a small maelstrom whirlpool.

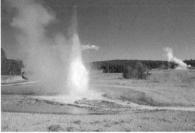

Below: Crested Pool is 42 feet (13 m) deep. Above-right: Sawmill Geyser.

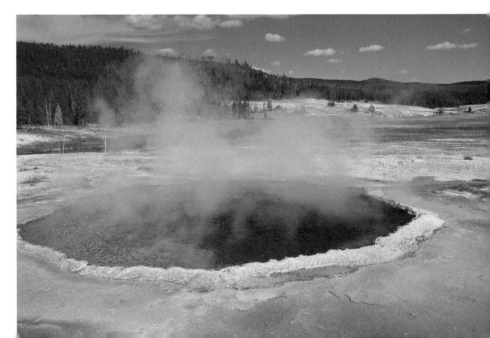

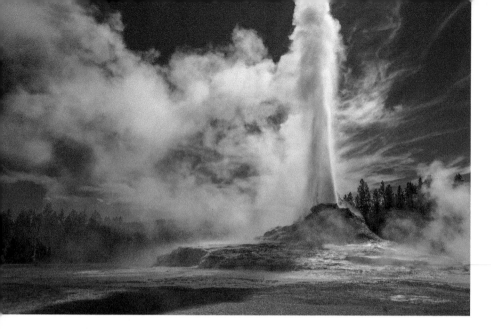

Castle Geyser is a "cone" geyser, where large deposits of geyserite sinter have created a raised base in the shape of a cone. When this geyser was named, the cone looked like a castle.

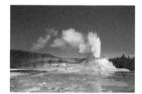

To capture atmospheric and artistic photos like these, get the sun directly behind the geyser, and entirely obscured by the water and/or steam. This "backlighting" makes the water glow and helps separate the subject from the background. Steven Spielberg will be proud of you.

✉ **Addr:**	Upper Geyser Basin, Yellowstone NP WY 82190	♀ **Where:**	44.46387 -110.836674
❷ **What:**	Geyser	◑ **When:**	Anytime
👁 **Look:**	Southeast	W **Wik:**	Castle_Geyser

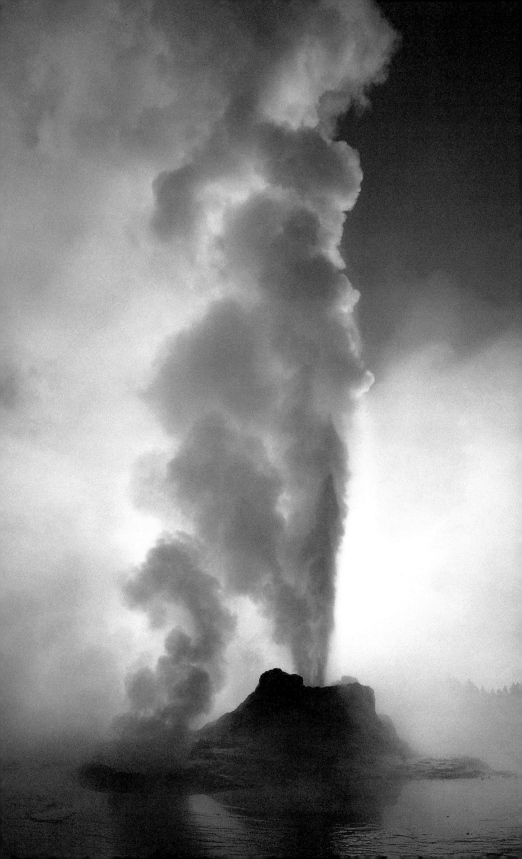

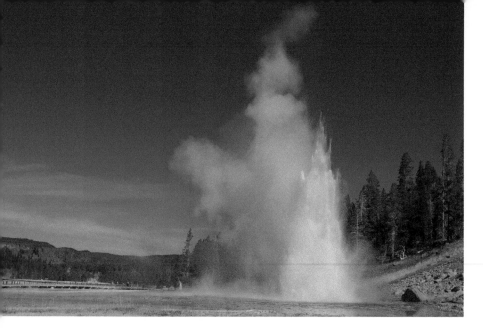

Giant Geyser is the tallest geyser in Upper Geyser Basin, and the second tallest in the world (after Steamboat Geyser, about 19 miles / 30 km north). Giant Geyser shoots hot water up to 250 feet (76 m) high. But eruptions are infrequent, so you are more likely to photograph the "giant" geyserite cone, about 12 feet tall.

Geysers occur when groundwater get heated by magma in an underground reservoir that acts like a pressure cooker. When steam bubbles escape, pressure is reduced and the superheated water flashes into steam and explodes out of the geyser vent.

✉ **Addr:**	Upper Geyser Basin, Yellowstone NP WY 82190	♀ **Where:**	44.470679 -110.840841
❓ **What:**	Geyser	☽ **When:**	Afternoon
👁 **Look:**	East	W **Wik:**	Giant_Geyser

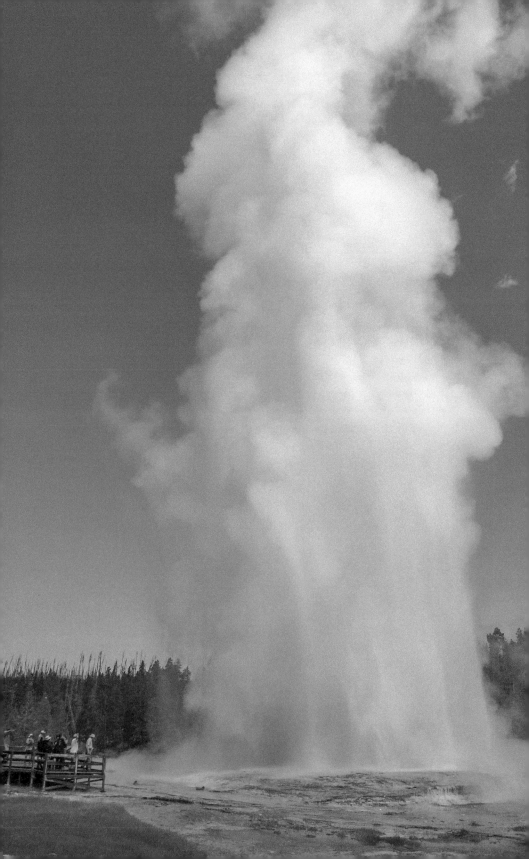

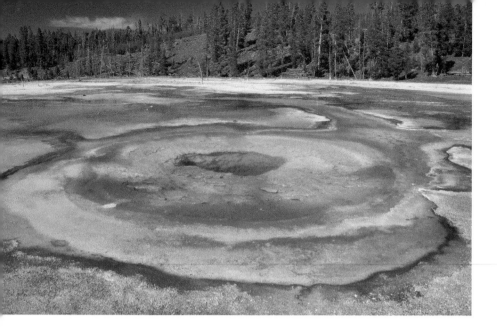

Chromatic Spring is a multi-colored hot spring, between Grand Geyser and Giant Geyser. The orange, yellow and green colors come from microbial mats — different types of bacteria which grow in rings of different water temperature. In this case, green bacteria grows in the hottest water at the center, and orange bacteria in the cooler periphery.

Nearby is the linked and larger (but less colorful) Beauty Pool, perhaps the largest spring in the Upper Geyser Basin.

✉ **Addr:**	Upper Geyser Basin, Yellowstone NP WY 82190	♀ **Where:**	44.468511 -110.839365	
❷ **What:**	Hot spring	◑ **When:**	Afternoon	
👁 **Look:**	North-northeast	W **Wik:**	Chromatic_Spring	

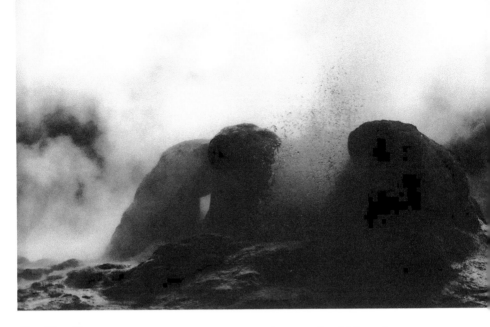

Grotto Geyser is a fountain-type geyser just north of Giant Geyser. This was one of the first seven geysers named in 1870 by the Washburn-Langford-Doane Expedition. Nathaniel Langford said Grotto Geyser "was so named from its singular crater of vitrified sinter, full of large, sinuous apertures."

I would have chosen the name *Alien* Geyser, for its resemblance to the derelict alien ship in the 1979 movie. Another reason not to approach the geysers.

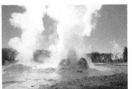

✉ **Addr:**	Upper Geyser Basin, Yellowstone NP WY 82190	♀ **Where:**	44.471839 -110.842039
❓ **What:**	Geyser	◑ **When:**	Anytime
👁 **Look:**	Southeast	W **Wik:**	Grotto_Geyser

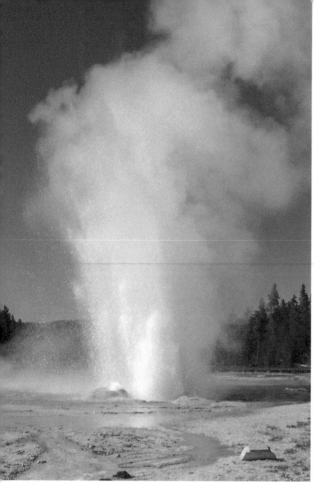

Daisy Geyser is the second-most predictable geyser in the park, usually erupting every few hours with +/-30 minutes accuracy.

Located about 1,000 feet (300 m) west of Grotto Geyser, Daisy has its own group which includes Splendid Geyser, Comet Geyser and Punch Bowl Spring.

✉ **Addr:**	Upper Geyser Basin, Yellowstone NP WY 82190	♀ **Where:**	44.469956 -110.844115	
❷ **What:**	Geyser	◑ **When:**	Afternoon	
👁 **Look:**	Southeast	🆆 **Wik:**	Daisy_Geyser	

Punch Bowl Spring

Punch Bowl Spring is 1,400 feet (420 m) west of Daisy Geyser, offset in partly wooden terrain.

Standing about five-feet tall with an 18-inch raised rim of sinter and hot bubbling water, the eight-foot-wide pool looks like a Halloween party punch bowl. Beware this witch's cauldron.

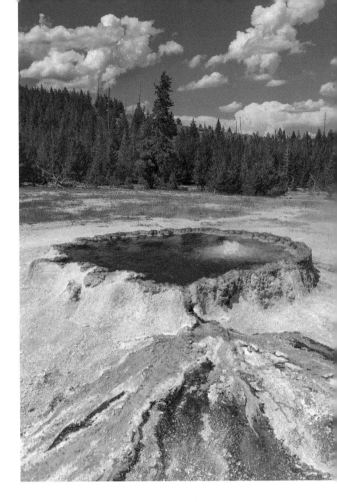

✉ **Addr:**	Upper Geyser Basin, Yellowstone NP WY 82190	♀ **Where:**	44.469368 -110.848668
❓ **What:**	Hot spring	☾ **When:**	Morning
👁 **Look:**	Northwest	↔ **Far:**	4 m (13 feet)

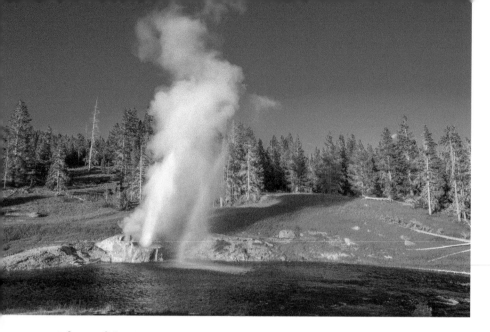

Riverside Geyser is the most scenic geyser in Yellowstone National Park, erupting from the banks of the Firehole River. You can photograph the scene from a gravel viewing area (above) and a bridge (below), both along the main trail.

Riverside Geyser shoots steam and water to heights of 75 feet (23 m) in an arch over the river, sometimes causing brilliant rainbows.

This is one of the most reliable geysers in the park having, like Old Faithful, a separate and undisturbed supply of groundwater. The eruptions occur every 6-1/2 hours, with +/-30 min accuracy.

✉ **Addr:**	Upper Geyser Basin, Yellowstone NP WY 82190	♀ **Where:**	44.4733378 -110.8414232
❓ **What:**	Geyser	⏲ **When:**	Afternoon
👁 **Look:**	East-northeast	W **Wik:**	Riverside_Geyser

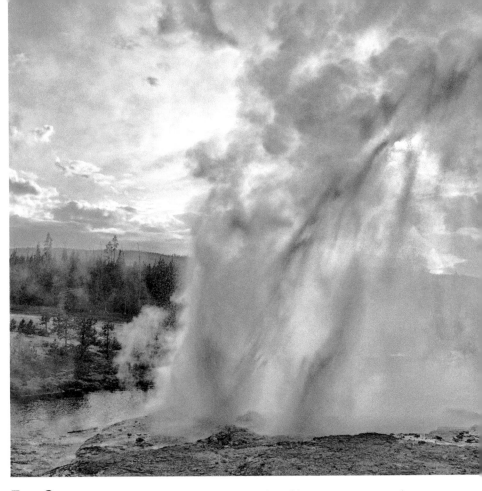

Fan Geyser has six vents shooting a curtain of hot water next to the Firehole River. Along with neighboring Mortar Geyser, Fan Geyser is easily photographed from the boardwalk.

✉ **Addr:**	Upper Geyser Basin, Yellowstone NP WY 82190	♀ **Where:**	44.4744475 -110.8425525	
❓ **What:**	Geyser	◑ **When:**	Morning	
👁 **Look:**	Southwest	W **Wik:**	Fan_and_Mortar_Geysers	

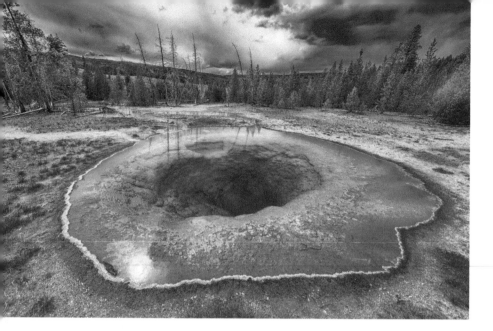

Morning Glory Pool is a white-rimmed hot spring colored with orange, yellow and green bacteria. You'll need a wide-angle lens here as the spring is 20 feet in diameter and a few feet from the raised boardwalk viewing platform.

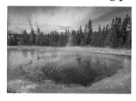

The pool was named by Mrs E. N. McGowan, wife of Assistant Park Superintendent, Charles McGowan for its resemblance to the morning glory flower, although that was in 1883 when the pool was blue.

This marks the end of the paved trail and a good point to return back to Old Faithful.

✉ **Addr:**	Upper Geyser Basin, Yellowstone NP WY 82190	♀ **Where:**	44.475009 -110.843490
❷ **What:**	Geothermal pool	⦿ **When:**	Morning
👁 **Look:**	North-northwest	Ⓦ **Wik:**	Morning_Glory_Pool

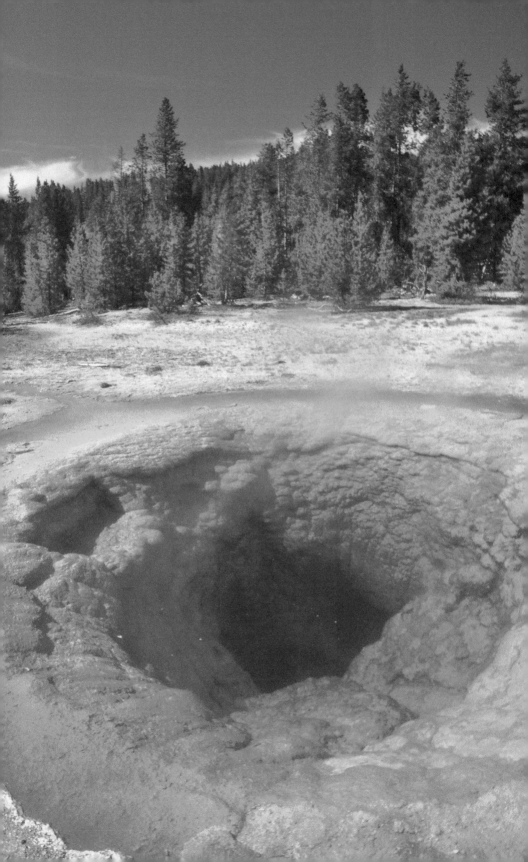

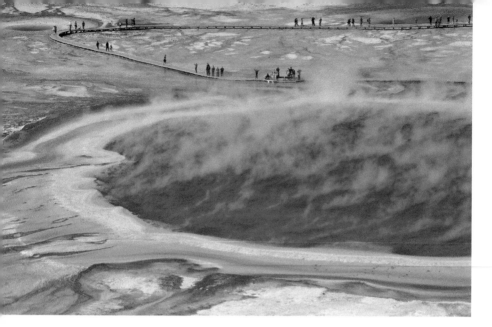

Grand Prismatic Spring is the largest hot spring in the United States, and the third largest in the world. At approximately 370 feet (110 m) in diameter and 160 feet (50 m) deep, it is the largest photographic geothermal feature in Yellowstone National Park.

The size means that you have to photograph from unusually far away. Fortunately, there is an excellent overlook to the southwest. From Grand Prismatic Spring Parking Lot, drive south 1.5 miles (2.3 km) to Fairy Falls Trailhead, then hike 0.8 miles (1.3 km) up Fairy Falls Trail to Grand Prismatic Spring Overlook.

Use flowers or trees for a foreground, or zoom in for a detail shot including people for dramatic scale.

✉ **Addr:**	Midway Geyser Basin, Yellowstone NP WY 82190	♥ **Where:**	44.523525 -110.840067
❓ What:	Hot spring	☽ **When:**	Afternoon
👁 **Look:**	Northeast	W **Wik:**	Grand_Prismatic_Spring

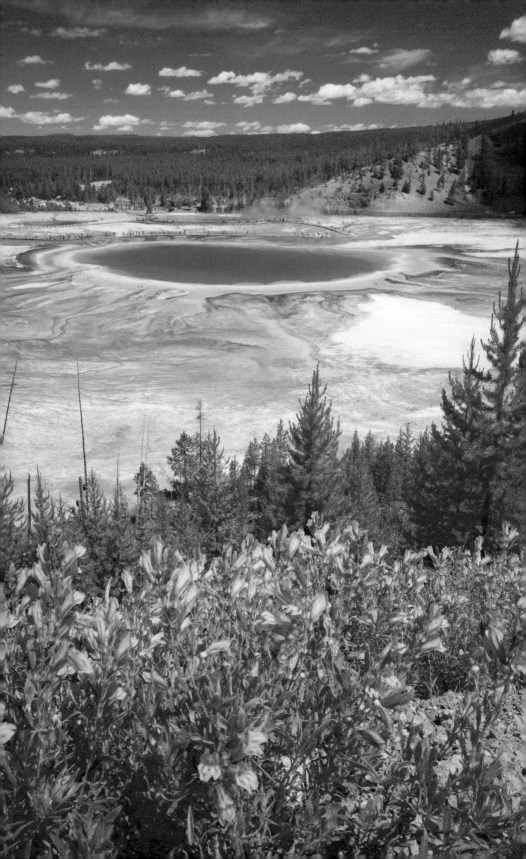

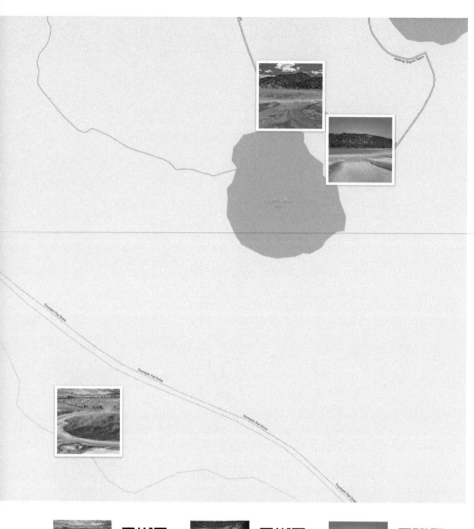

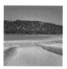

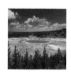

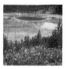

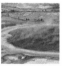

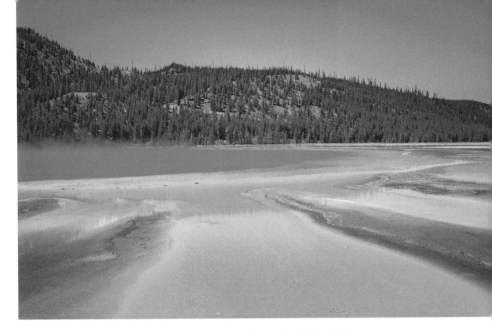

From a boardwalk on the north edge, you can take colorful details shots.

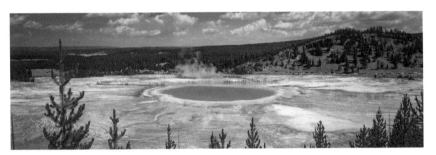

The vivid colors are from microbial mats on the cooler edges.

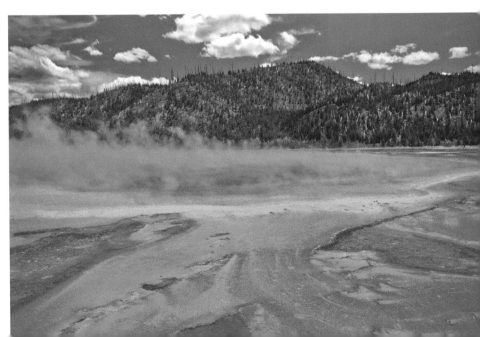

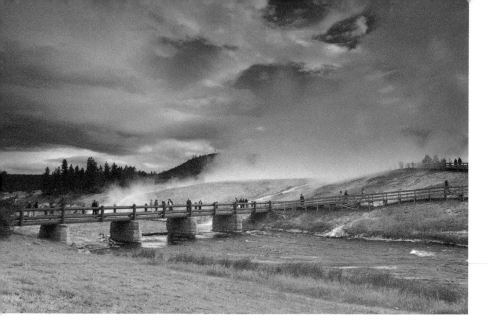

Midway Geyser Basin Boardwalk is a loop trail of about one mile (1.6 km), past Grand Prismatic Spring as well as Excelsior Geyser Crater, Opal Pool and Turquoise Pool.

From Old Faithful, take U.S. 191 north about 7 miles (11 km) to the Grand Prismatic Spring Parking Lot.

The picture above is from the parking lot looking toward the pedestrian bridge over the Firehole River. The first feature you encounter is Excelsior Geyser Crater (right), as photographed from the boardwalk to the west.

✉ **Addr:**	Midway Geyser Basin, Yellowstone NP WY 82190	♀ **Where:**	44.52535 -110.837422
❷ **What:**	Boardwalk	◑ **When:**	Morning
👁 **Look:**	Southwest	↔ **Far:**	70 m (230 feet)

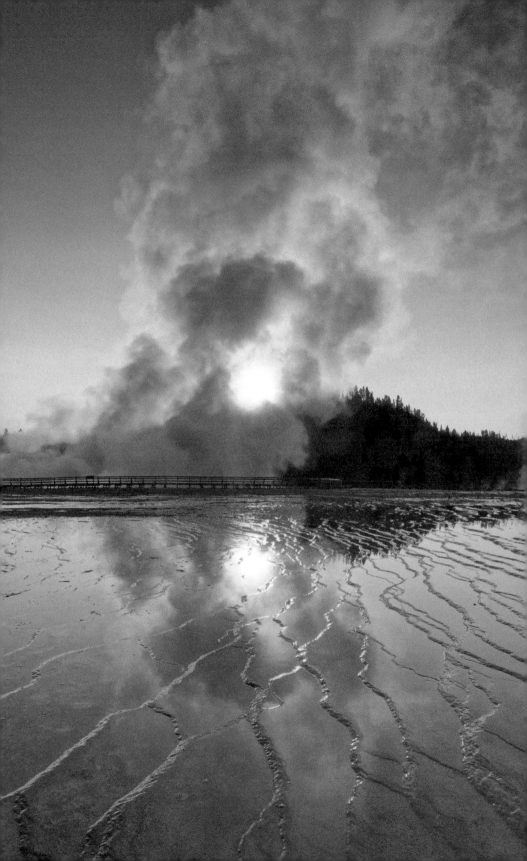

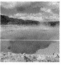
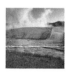

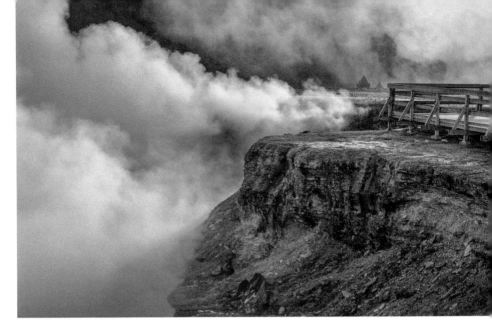

Excelsior Geyser Crater cliff from the south.

Turquoise Pool (above) and Opal Pool (below).

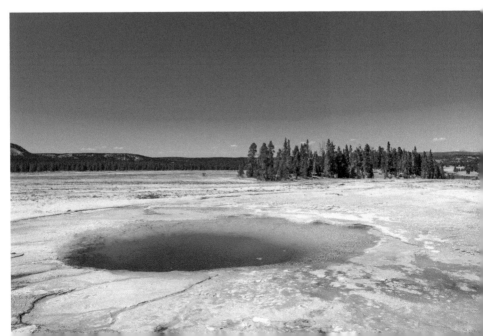

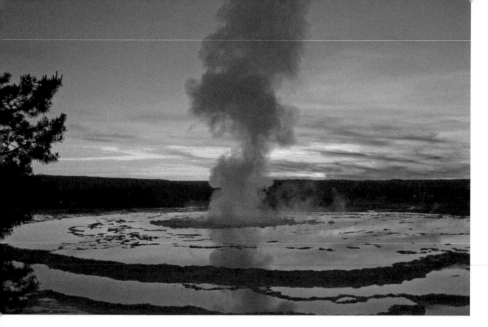

Firehole Lake Drive is a road through Lower Geyser Basin, which is north of Upper and Midway Geyser Basins. The geothermal features are more spread out here, necessitating a 3.75-mile-long (6 km) drive past Great Fountain Geyser, White Dome Geyser and Pink Cone Geyser.

These two pictures are of Great Fountain Geyser, which erupts at approximately 11-hour intervals.

The later pictures are of White Cone Geyser (top) and Pink Cone Geyser (bottom).

✉ **Addr:**	Lower Geyser Basin, Yellowstone NP WY 82190	♀ **Where:**	44.539073 -110.802672
❷ **What:**	Road	◔ **When:**	Anytime
👁 **Look:**	West-southwest	W **Wik:**	White_Dome_Geyser

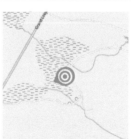
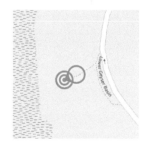

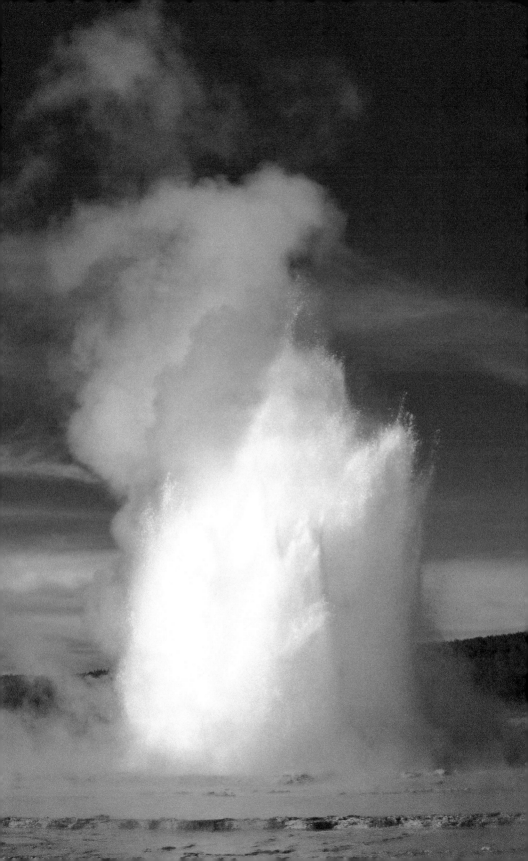

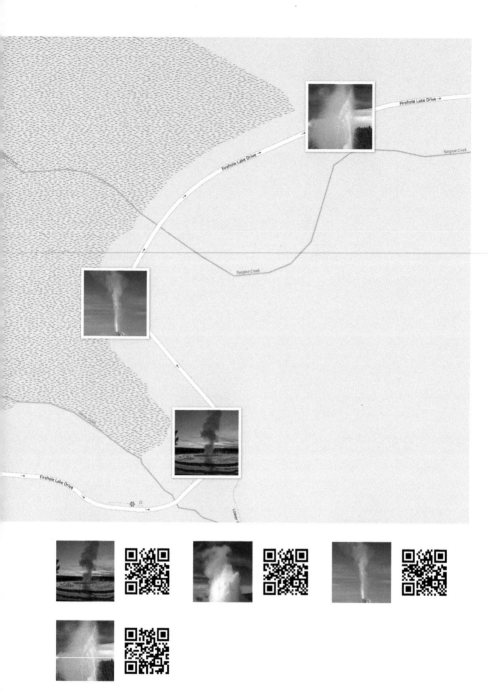

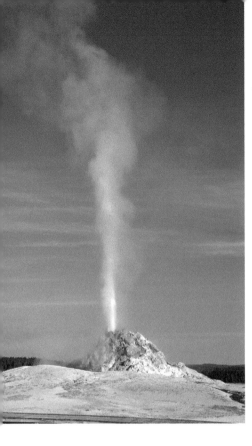

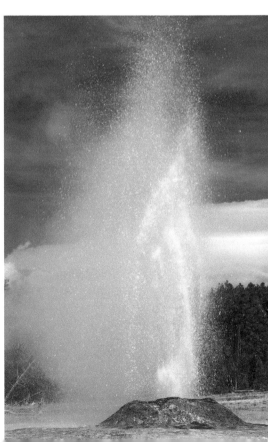

Lower Geyser Basin > Firehole Lake Drive

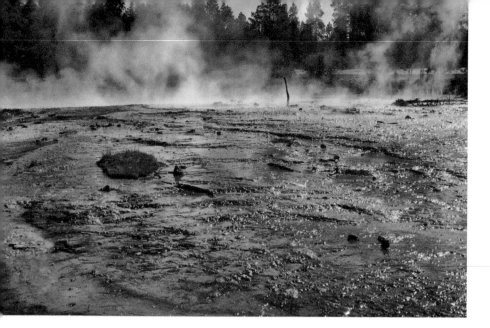

Fountain Paint Pot Trail is another part of Lower Geyser Basin, just north of Firehole Lake Drive. A 2/3-mile (1 km) loop boardwalk takes you past Fountain Paint Pot (above), Silex Spring (below-left) and Clepsydra Geyser (below-right).

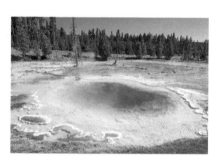
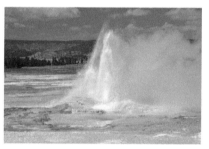

✉ **Addr:**	Lower Geyser Basin, Yellowstone NP WY 82190	♀ **Where:**	44.550251 -110.806032
❓ **What:**	Trail	☽ **When:**	Afternoon
👁 **Look:**	Southeast	W **Wik:**	Fountain_Paint_Pot

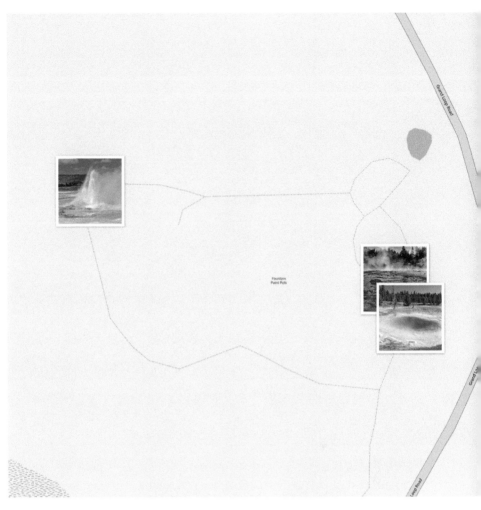

Fountain
Paint Pots

 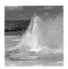

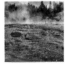 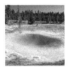

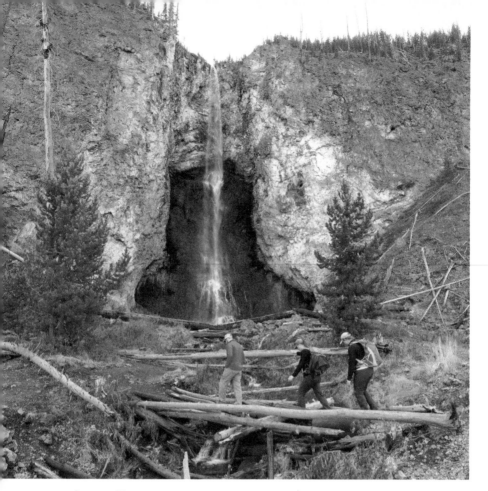

Fairy Falls is a 197-foot-tall (60 m) waterfall located about two miles (3.2 km) west of Grand Prismatic Spring Overlook. This is one of several photogenic features on the western edge of Geyser Basin.

✉ **Addr:**	Fairy Falls Trail, Yellowstone NP WY 82190	♀ **Where:**	44.52525 -110.869614	
❷ **What:**	Waterfall	◐ **When:**	Morning	
👁 **Look:**	South-southwest	↔ **Far:**	60 m (200 feet)	

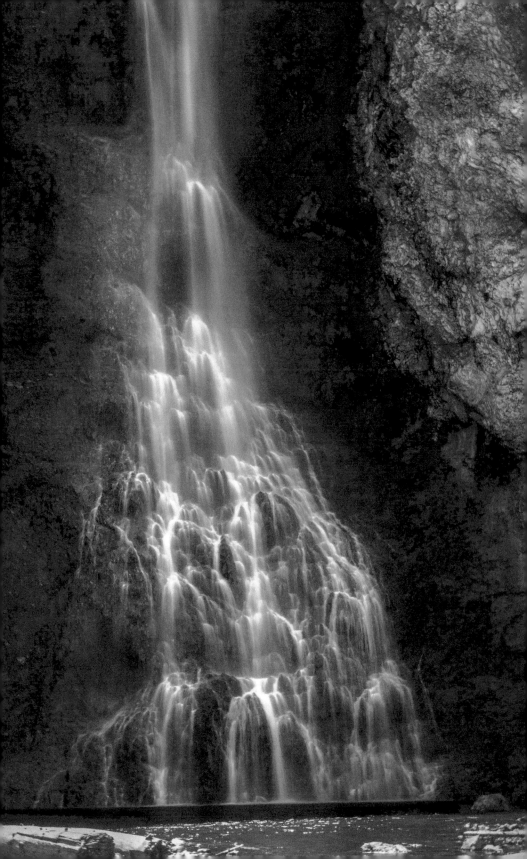

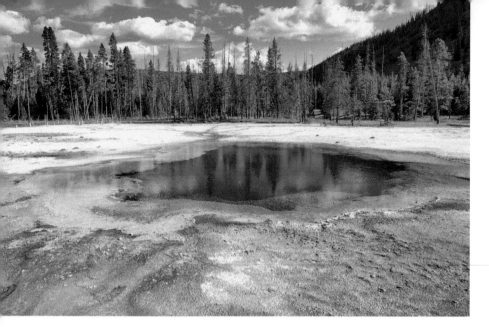

Black Sand Basin is part of Upper Geyser Basin but located about 1.3 miles (2.2 km) west of Old Faithful in a separate area.

The main attraction is Emerald Pool (above), which is 27x38 feet wide with a depth of 25 feet. Yellow sulfur deposits combine with the reflected blue light to tint the hot spring a magnificent emerald green.

Nearby, Rainbow Pool (right) has a runoff which flows under the boardwalk, making an excellent foreground and leading line.

The walk around Black Sand Basin is about a 1/2-mile (800 m) round trip.

✉ **Addr:**	Black Sand Basin, Yellowstone NP WY 82190	♀ **Where:**	44.462607 -110.854779
❷ **What:**	Basin	◑ **When:**	Anytime
👁 **Look:**	North-northeast	↔ **Far:**	23 m (75 feet)

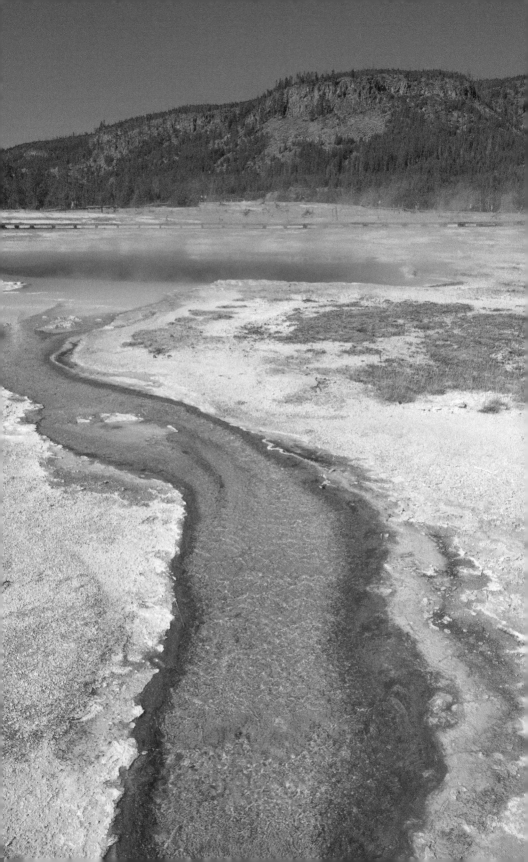

 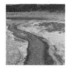

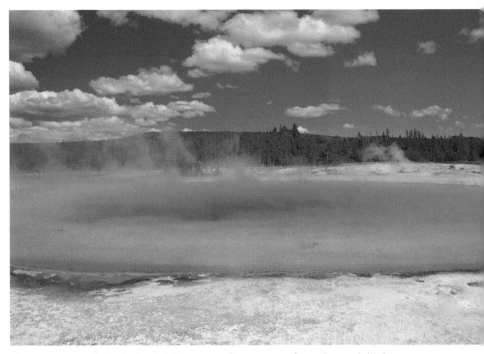

Above: Sunset Lake is the basin's largest pool, at 145x191 feet. The pool discharges into Iron Creek, and overflows into Rainbow Pool creating a large microbial mat between the two pools. Below: Emerald Pool from the northeast.

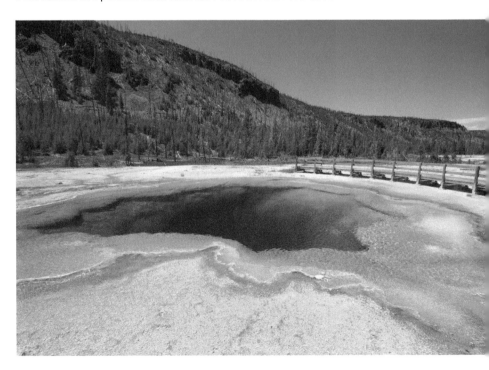

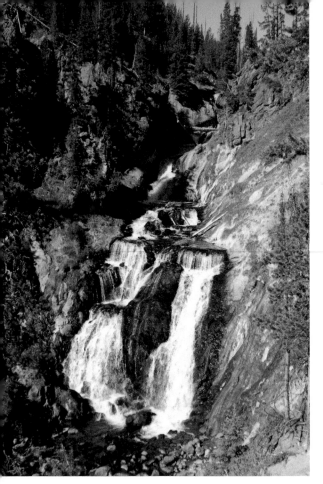

Mystic Falls is a 70-foot cascade type waterfall on the Little Firehole River.

The waterfall is reached via the 1.2-mile-long (1.9 km) Mystic Falls Trail which starts at Biscuit Basin in the Upper Geyser Basin. Hike the loop in a clockwise direction for better views.

✉ **Addr:**	Mystic Falls Trail, Yellowstone NP WY 82190	♀ **Where:**	44.484365 -110.872841
❷ **What:**	Waterfall	☽ **When:**	Morning
👁 **Look:**	Southwest	Ｗ **Wik:**	Mystic_Falls

Kepler Cascades is a waterfall on the Firehole River, about 2.6 miles south of Old Faithful. The 50-foot-tall (15 m) cascade is easily photographed from a viewing deck just 120 feet from a parking area along the Great Loop Road, between Old Faithful and the West Thumb of Yellowstone Lake.

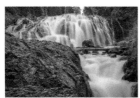

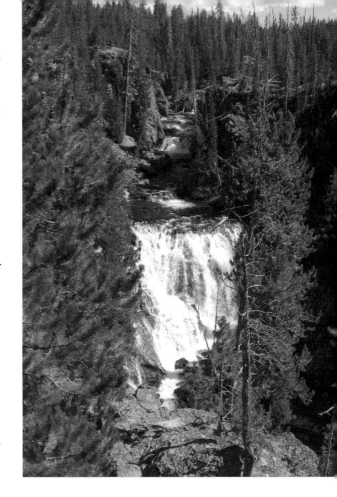

Kepler Cascades faces north-northwest and has tall trees either side, so midday is best to get light on the water.

✉ **Addr:**	U.S. Highway 191, Yellowstone NP WY 82190	♀ **Where:**	44.446094 -110.806019	
❷ **What:**	Waterfall	◑ **When:**	Afternoon	
👁 **Look:**	South	W **Wik:**	Kepler_Cascades	

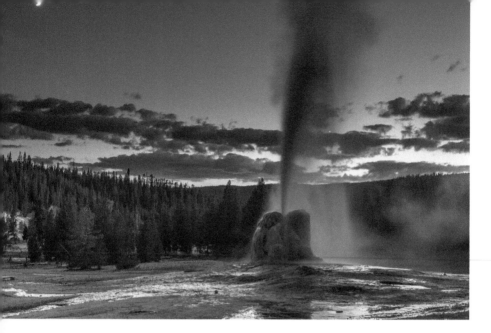

Lone Star Geyser

Lone Star Geyser is a backcountry geyser located in the Lone Star Geyser Basin about three miles (4.8 km) southeast of Old Faithful.

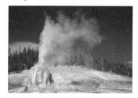

Starting at the trailhead near Kepler Cascades, an old service road provides a pleasant and flat 2.7-mile (4.2 km) hike or bike ride to the geyser. Eruptions are about every three hours, so schedule your visit after getting a prediction time from the National Park Service.

✉ **Addr:**	Lone Star Geyser Basin, Yellowstone NP WY 82190	♀ **Where:**	44.4182436 -110.8065277
❷ **What:**	Geyser	☾ **When:**	Sunset
👁 **Look:**	Southwest	𝕎 **Wik:**	Lone_Star_Geyser

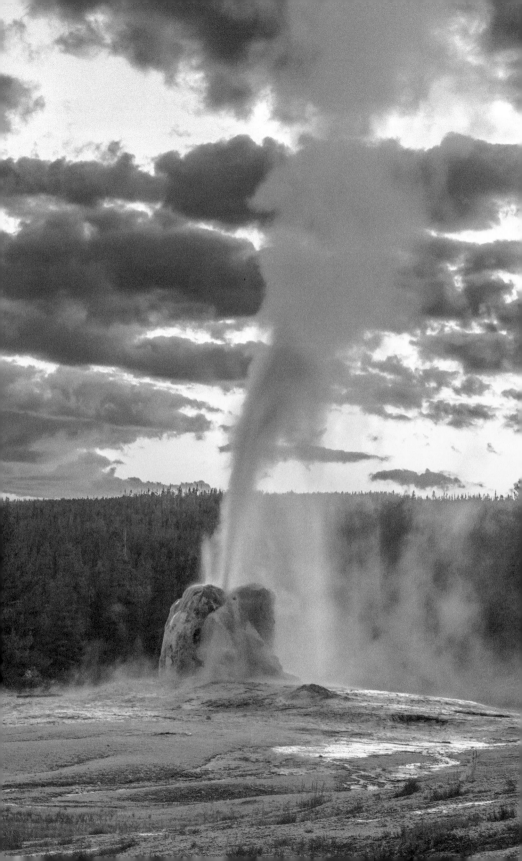

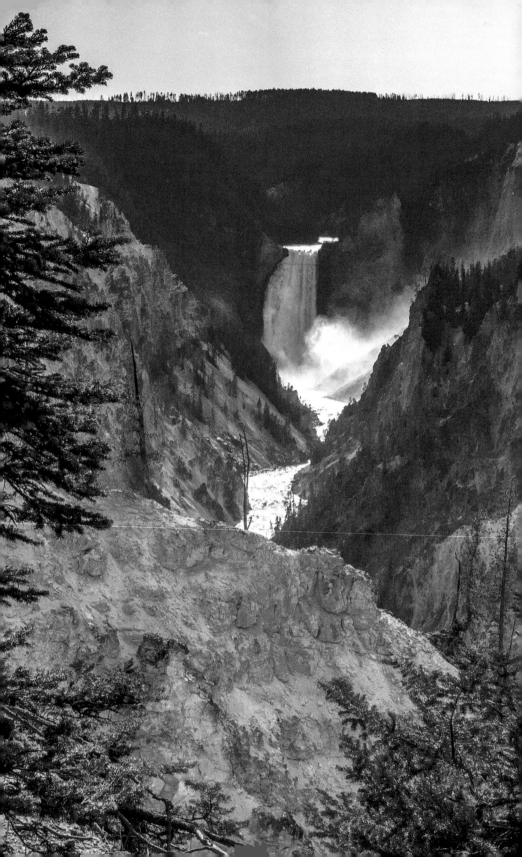

Grand Canyon
of the
Yellowstone

Lower Yellowstone Falls from Artist Point on the South Rim

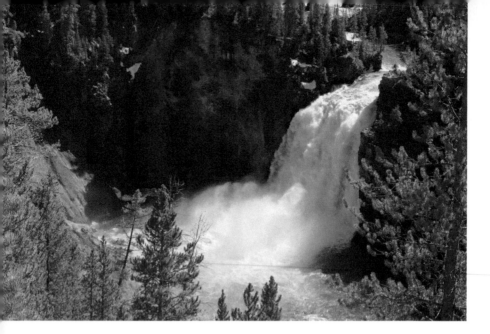

Upper Falls View is the easiest place to photograph the upper section of Yellowstone Falls in the Grand Canyon of the Yellowstone.

From the north side of Yellowstone Lake, follow the Yellowstone River downstream along Grand Loop Road through Hayden Valley, and turn east on South Rim Drive. After 2/3-mile (1 km), a large parking area to the north provides access to three viewpoints.

A short, flat, paved walk of about 300 feet (100 m) brings you to Upper Falls View. From this paved cliff-top area you can see — and photograph — 900 feet (280 m) southwest to Upper Falls.

The waterfall faces northeast, so morning provides the best light.

✉ **Addr:**	South Rim Grand Canyon, Yellowstone NP WY 82190	♀ **Where:**	44.714622 -110.497146	
◑ **When:**	Morning	👁 **Look:**	Southwest	
W **Wik:**	Grand_Canyon_of_the_Yellowstone	↔ **Far:**	290 m (940 feet)	

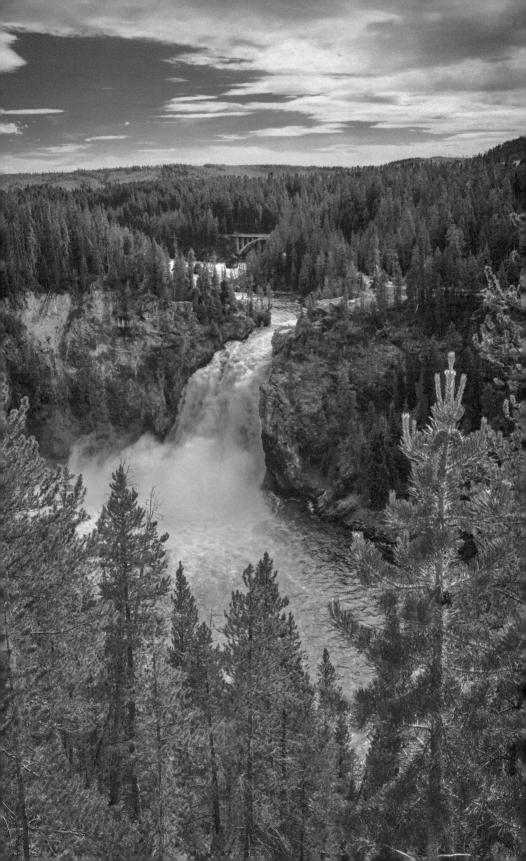

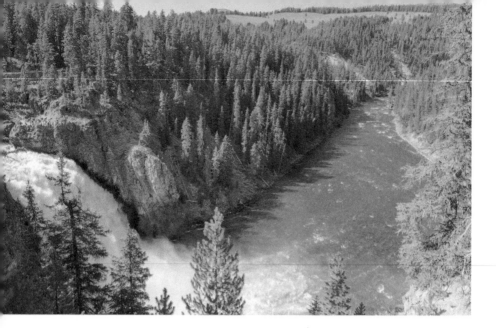

South Rim Trail View

South Rim Trail View is about 1,500 feet (440 m) southwest from Upper Falls View, along South Rim Trail. There is a wooden viewing deck and a side-on lookout over Upper Yellowstone Falls, about 380 feet (120 m) away. Plunging 109 feet (33 m), Upper Falls marks the junction between a hard rhyolite lava flow and weaker glassy lava that has been more heavily eroded.

The lower falls are a quarter mile (400 m) downstream but, due to an S-bend in the river, there is not a good viewpoint to photograph both falls together.

✉ **Addr:**	South Rim Grand Canyon, Yellowstone NP WY 82190	📍 **Where:**	44.712386 -110.498404
🕐 **When:**	Morning	👁 **Look:**	West-northwest
↔ **Far:**	120 m (390 feet)		

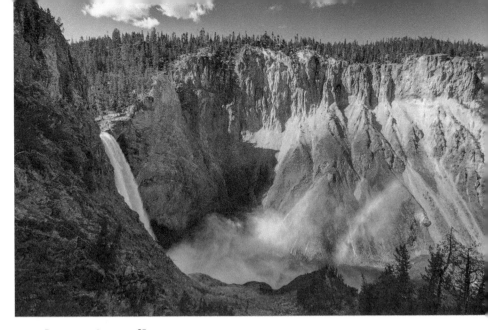

Uncle Tom's Trail includes a metal stairway attached to the cliff on the south side of Lower Yellowstone Falls. Starting from the parking lot for Upper Falls View, hike about 1/3-mile (500 m) along a trail and the stairs to a small, metal viewing deck, where you are about 500 feet (150 m) from Lower Falls.

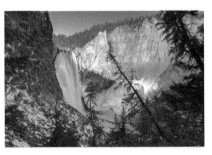
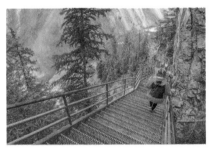

✉ **Addr:**	South Rim Grand Canyon, Yellowstone NP WY 82190	♀ **Where:**	44.717839 -110.494566
❓ **What:**	Trail	🕐 **When:**	Morning
👁 **Look:**	West	W **Wik:**	Yellowstone_Falls#Lower_Yellowstone_Falls

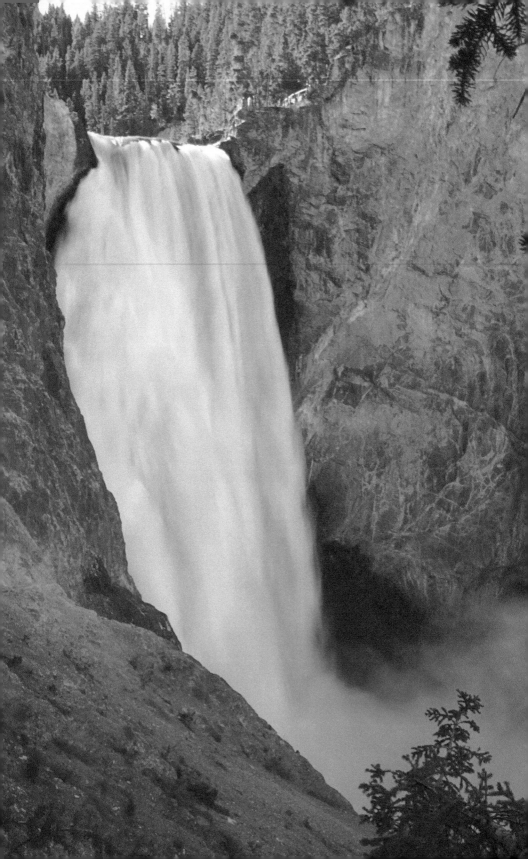

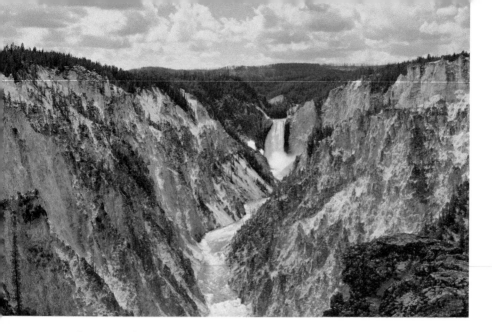

Artist's Point is the classic view of Lower Yellowstone Falls, made famous by an 1871 painting by Thomas Moran.

A parking lot at the end of South Rim Drive offers a walk of about 600 feet (180 m) to a paved overlook. From this cliff edge, you can see about a mile west up the Grand Canyon of the Yellowstone, with its namesake yellow rock walls.

The color of the volcanic rock comes from iron compounds which are oxidizing, literally rusting. Starting at the 308-foot-high (94 m) Lower Yellowstone Falls, the Grand Canyon extends 24 miles (39 km), with a depth up to 1,200 ft (370 m).

✉ **Addr:**	South Rim Grand Canyon, Yellowstone NP WY 82190	♥ **Where:**	44.721254 -110.479395
❓ **What:**	Viewpoint	◑ **When:**	Morning
👁 **Look:**	West-southwest	W **Wik:**	Artist_Point

Yellowstone National Park

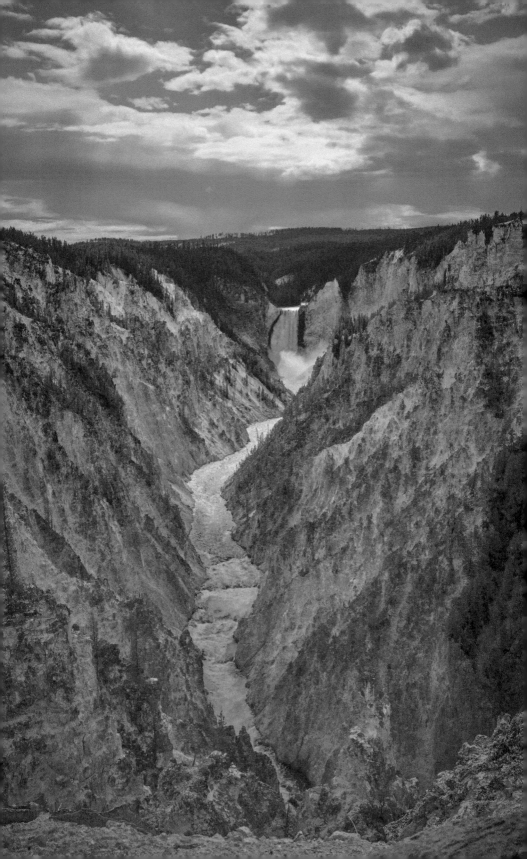

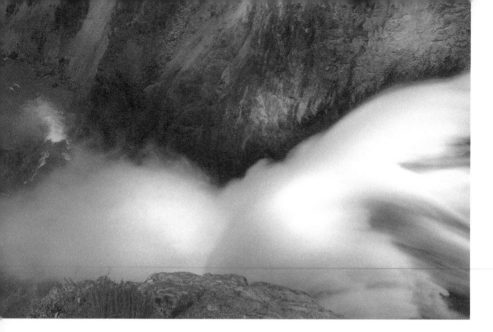

Brink of the Upper Falls is a viewpoint on the north rim that is almost too close to the edge for a good photograph.

From Grand Loop Road north of the Yellowstone River, enter Brink of Upper Falls Parking Lot and walk about 700 feet (200 m) south to a paved viewing deck. You'll need a wide-angle lens, and bravery, to photograph the 109 feet (33 m) drop.

The shot above uses a slow shutter speed to deliberately blur the water into a romantic image.

✉ **Addr:**	Upper Yellowstone Falls, Yellowstone NP WY 82190	♀ **Where:**	44.713017 -110.49963	
❷ **What:**	Viewpoint	◑ **When:**	Morning	
👁 **Look:**	South	W **Wik:**	Yellowstone_Falls#Upper_Yellowstone_Falls	

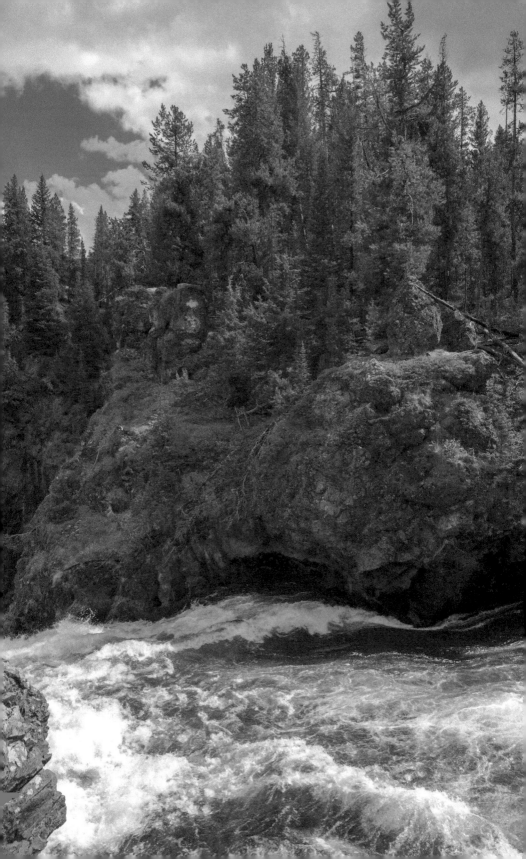

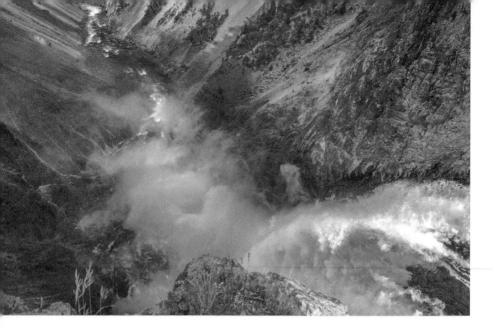

Brink of the Lower Falls is a similar but even more impressive overlook, looking down 308 feet (94 m) of Lower Yellowstone Falls and the upper part of the Grand Canyon of the Yellowstone.

From Grand Loop road, take North Rim Drive to the first parking lot. A sign indicates the trail and an overlook (right). Walk about 1.2 miles (2 km) down the paved path to the paved viewpoint.

✉ **Addr:**	North Rim Grand Canyon, Yellowstone NP WY 82190	♀ **Where:**	44.718163 -110.496285
❓ **What:**	Viewpoint	◑ **When:**	Afternoon
👁 **Look:**	South-southeast	W **Wik:**	Yellowstone_Falls#Lower_Yellowstone_Falls

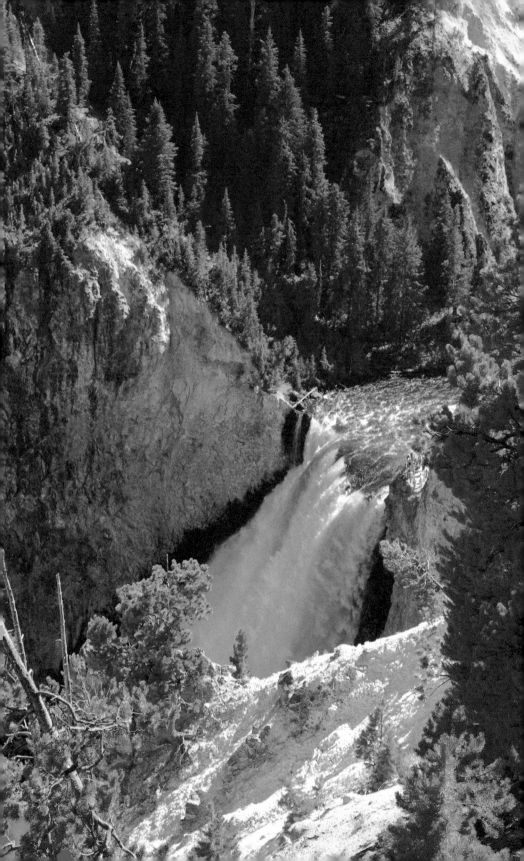

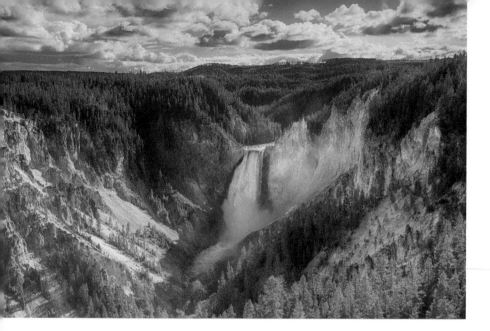

Lookout Point is another classic view of Lower Yellowstone Falls. This is very similar to the view from Artist's Point on the South Rim, but is half the distance closer to the waterfall.

From the second parking lot on North Rim Drive, walk an easy 320-foot-long (100 m) paved path to the viewing area. The cliffs and waterfall face east, so early morning gives you the best light.

The adventurous can descend a paved path and stairway about 1/3 mile (500 m) down to Red Rock Point, also called Lower Lookout Point, for a lower and closer view (right).

✉ **Addr:**	North Rim Grand Canyon, Yellowstone NP WY 82190	♀ **Where:**	44.720782 -110.488461
❓ **What:**	Viewpoint	☽ **When:**	Morning
👁 **Look:**	West-southwest	↔ **Far:**	0.68 km (0.43 miles)

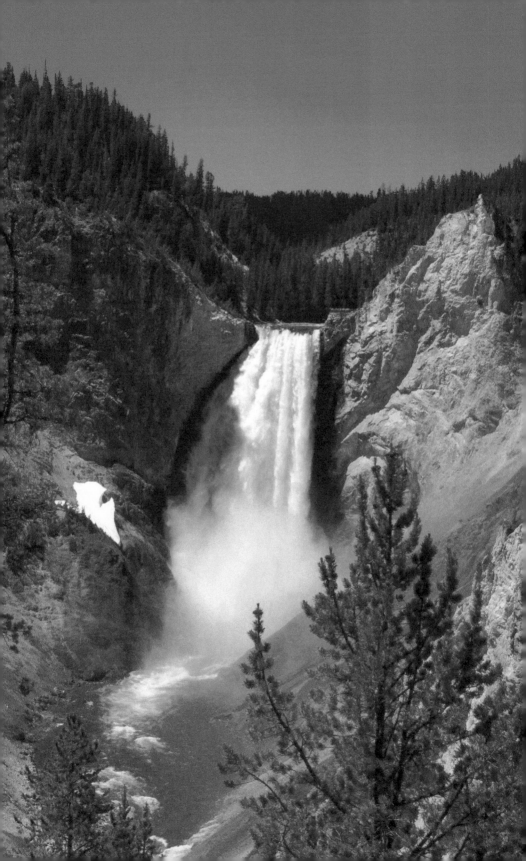

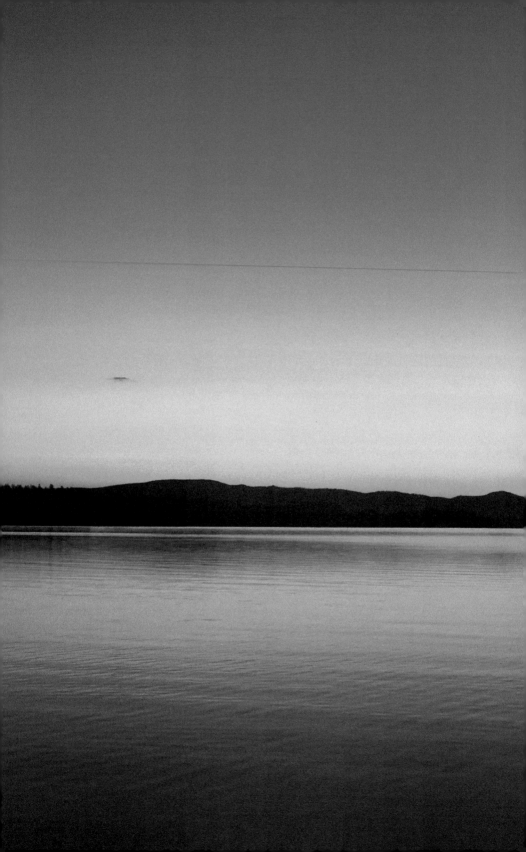

Yellowstone Lake

Yellowstone Lake at sunrise

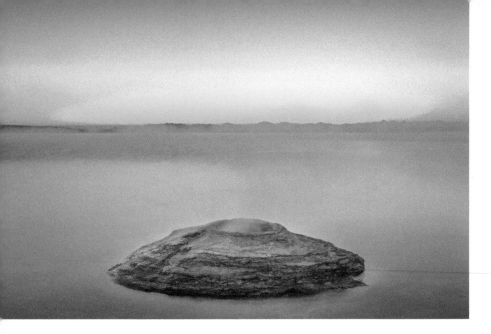

Fishing Cone is a particularly photogenic geyser, looking like a primordial island in Yellowstone Lake. Almost submerged by the lake's rising waters, the isolated cone is an ethereal sight at sunrise.

Fishing Cone is easily photographed from the boardwalk at West Thumb Geyser Basin, on the lake's west shore, by the road from Old Faithful.

Yellowstone Lake lies at the center of the park and is the largest freshwater lake above 7,000 ft (2,100 m) in North America. The lake fills part of a caldera of the the Yellowstone Supervolcano.

✉ **Addr:**	West Thumb Geyser Basin Trail, Yellowstone NP WY 82190	♀ **Where:**	44.4172652 -110.570277
❓ **What:**	Geyser	☽ **When:**	Sunrise
👁 **Look:**	West-southwest	W **Wik:**	Fishing_Cone

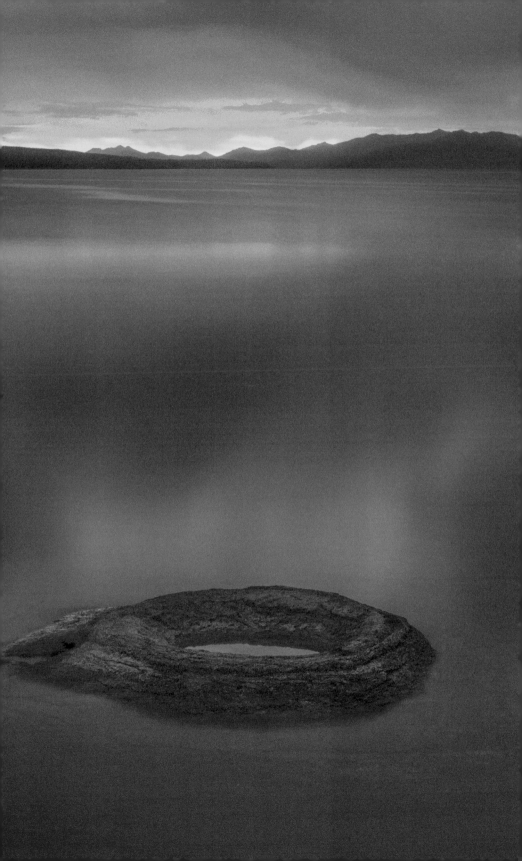

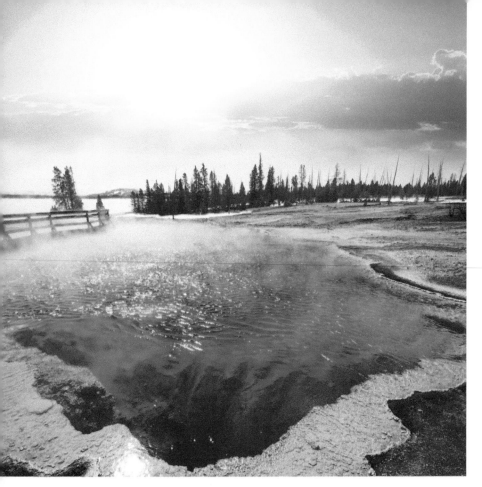

Black Pool is a hot spring on the western edge of Yellowstone Lake. From the west side, you can photograph the pool and the lake, with a boardwalk in between. A dark green color when it was named, the pool has since heated up and is now an intense blue color.

✉ **Addr:**	West Thumb Geyser Basin, Yellowstone NP WY 82190	♀ **Where:**	44.418184 -110.572084
❓ **What:**	Geothermal pool	☾ **When:**	Afternoon
👁 **Look:**	East	W **Wik:**	Black_Pool

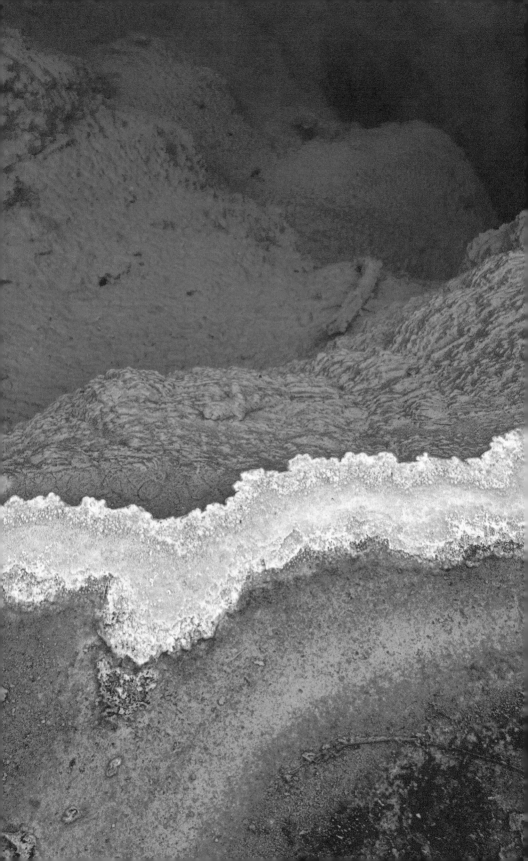

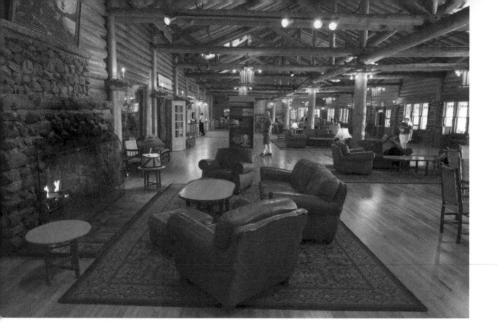

Lake Lodge is a mini Old Faithful Inn, made of local logs in a rustic style. Facing the north bank of Yellowstone Lake, the lobby is spacious and inviting, with leather chairs by a stone fireplace.

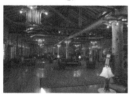

Photographing interiors is tricky since the light levels are low. Try standing your camera on a firm surface and using the self-timer to reduce camera shake.

✉ **Addr:**	459 Lake Village Road, Yellowstone NP WY 82190	♀ **Where:**	44.5548 -110.395861	
❓ **What:**	Lobby	⏱ **When:**	Anytime	
👁 **Look:**	North-northeast	↔ **Far:**	29 m (95 feet)	

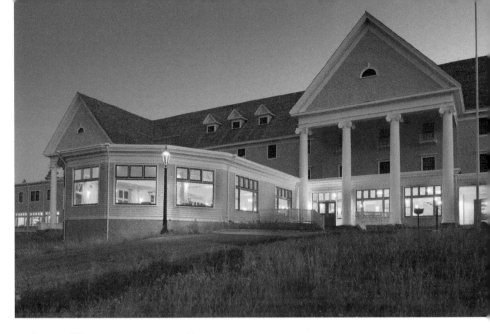

Lake Yellowstone Hotel is the oldest hotel in a national park. Known as "The Grand Old Lady of the Lake," the hotel opened in 1891 in a Colonial Revival style, based on the seaside and lakeside resorts in the Berkshires of Massachusetts, the Poconos of Pennsylvania, and New York's Long Island.

Robert Reamer, architect of the Old Faithful Inn, redesigned the hotel in 1903 and added a sunroom, now known as the Reamer Lounge, where guests can enjoy the ambiance of Yellowstone Lake.

✉ **Addr:**	6130 Roosevelt, Yellowstone NP WY 82190	♀ **Where:**	44.549355 -110.400077
❓ **What:**	Hotel	☾ **When:**	Anytime
👁 **Look:**	Northwest	W **Wik:**	Lake_Hotel

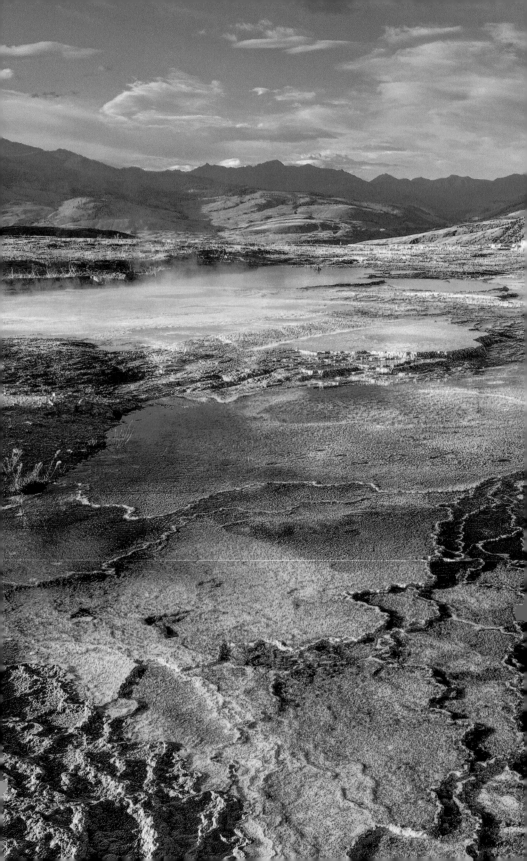

Mammoth
Hot Springs

Upper Terrace boardwalk viewpoint

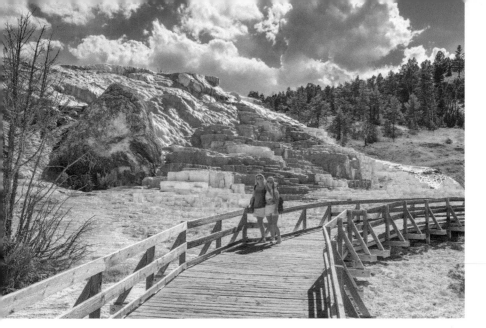

Minerva Terrace is the most photogenic feature of Mammoth Hot Springs, the largest known carbonate-depositing spring in the world. Created over thousands of years, this colorful stepped terrace can be photographed from the Lower Terraces Boardwalk (above) and Beaver Ponds Trail (right).

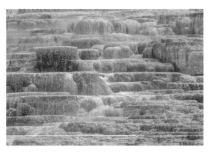 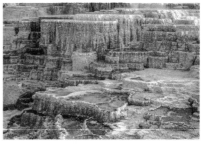

✉ **Addr:**	Mammoth Hot Springs, Yellowstone NP WY 82190	♀ **Where:**	44.972612 -110.705203
❓ **What:**	Hot spring terrace	◑ **When:**	Morning
👁 **Look:**	South	↔ **Far:**	20 m (66 feet)

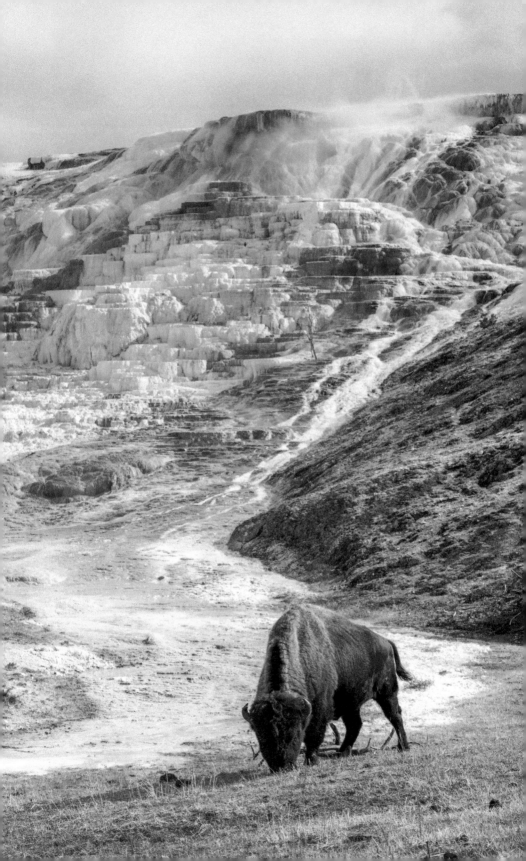

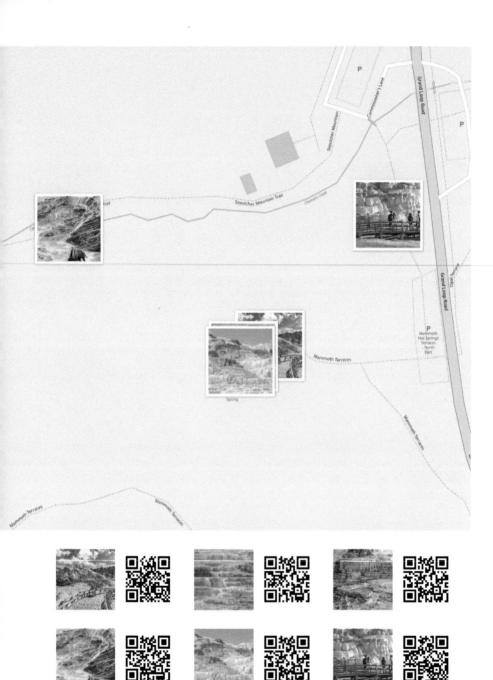

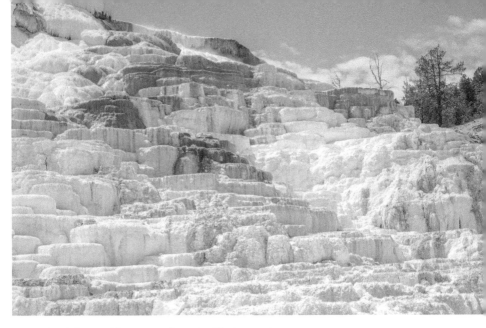

Travertine is layered limestone deposited by hot springs.

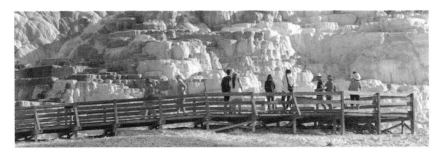

People on the boardwalk, photographed from the parking lot.

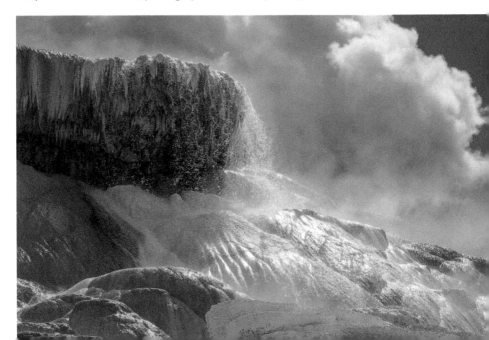

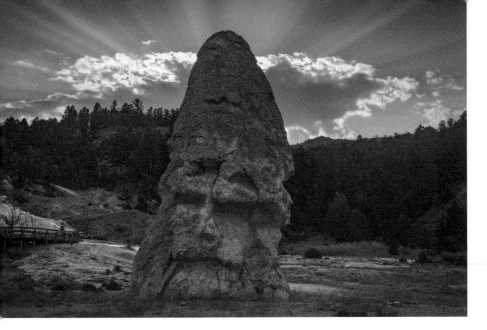

Liberty Cap is a 37-foot-high tower of travertine, named for its resemblance to the peasant caps worn during the French Revolution. The extinct hot spring cone stands sentinel in front of Minerva Terrace, by the parking lot.

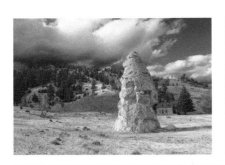 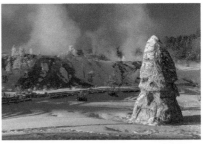

✉ **Addr:**	Mammoth Hot Springs, Yellowstone NP WY 82190	♀ **Where:**	44.9728534 -110.7040091	
❓ **What:**	Hot spring cone	◐ **When:**	Morning	
👁 **Look:**	West	↔ **Far:**	30 m (100 feet)	

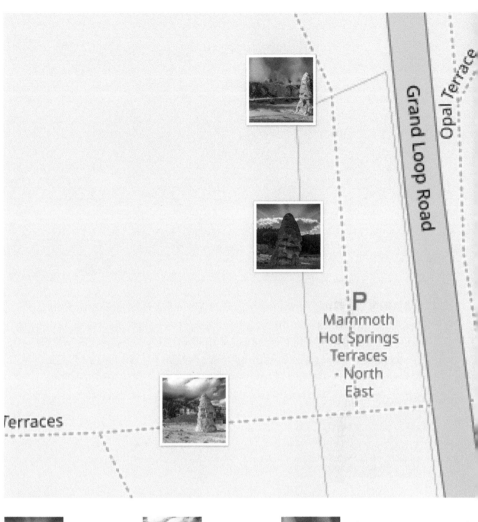

Grand Loop Road

Opal Terrace

P
Mammoth
Hot Springs
Terraces
· North
East

Terraces

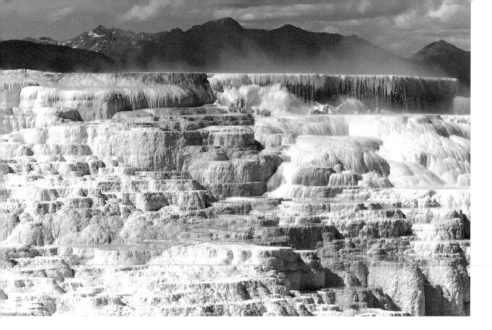

Canary Spring flows through the Main Terrace of Mammoth Hot Spring. Named for the the yellow filamentous algae growing along the edge of the spring, the cascading waters creates warm pools which feeds bacteria that tint the limestone orange, brown and red. The formation is constantly changing shape, as new rock is deposited.

✉ **Addr:**	Mammoth Hot Springs, Yellowstone NP WY 82190	♀ **Where:**	44.966753 -110.705082
❓ **What:**	Hot spring	🕐 **When:**	Morning
👁 **Look:**	Northwest	↔ **Far:**	40 m (110 feet)

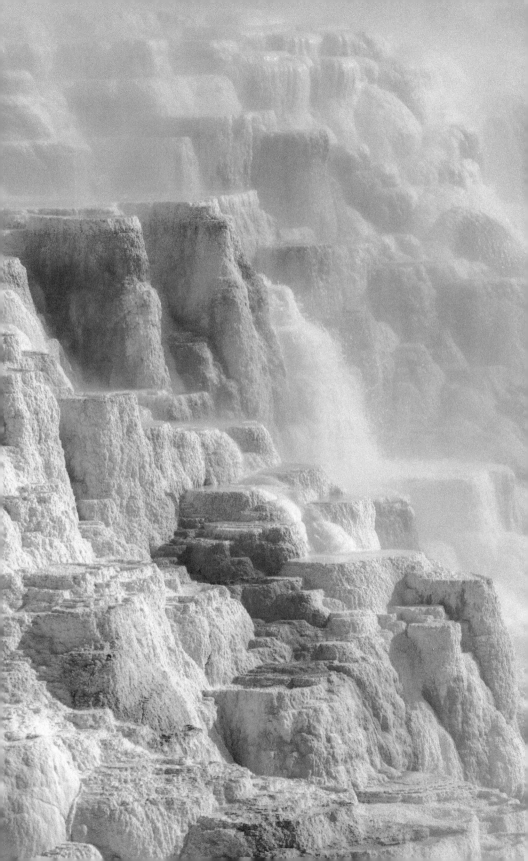

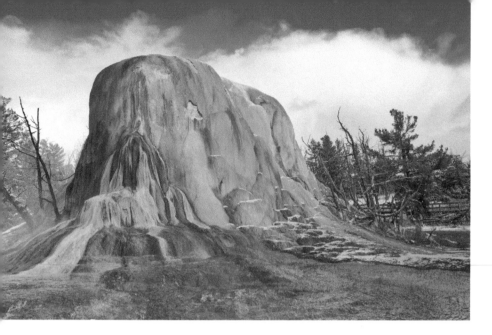

Orange Mound Spring is a hot spring most notable for its prominence above the ground, compared to the rest of the Mammoth Hot Springs, which are mostly flat and leveled terraces.

Thermally cooler than most springs in Yellowstone and at the Mammoth Hot Springs themselves, the elephant-shaped rock allows orange-tinted cyanobacteria to thrive and color the spring a darker shade of orange than the rest of the Mammoth Terraces. Depending on the nutrients that the bacteria receive, the color may change throughout the year.

These views are from a tarmac service road, part of the trail system on the western edge of the Main Terrace.

✉ **Addr:**	Mammoth Hot Springs, Yellowstone NP WY 82190	♀ **Where:**	44.966498 -110.715183	
❓ **What:**	Hot spring	◑ **When:**	Afternoon	
👁 **Look:**	East	W **Wik:**	Orange_Mound_Spring	

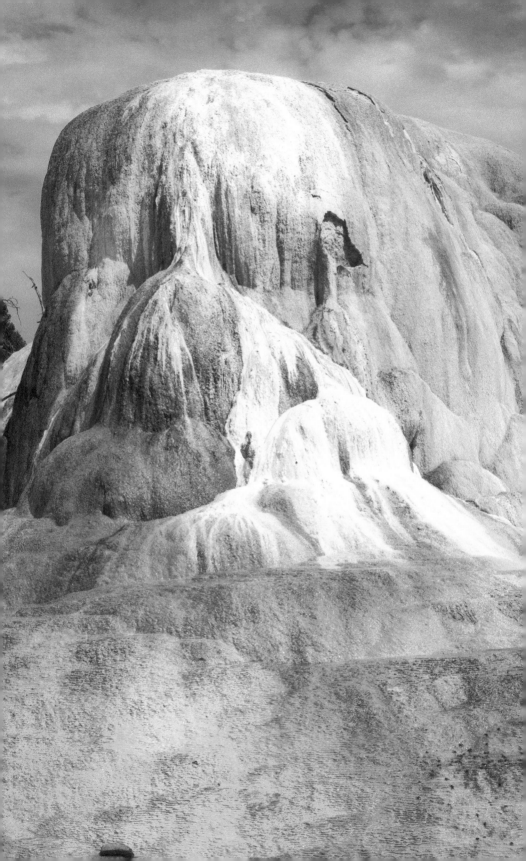

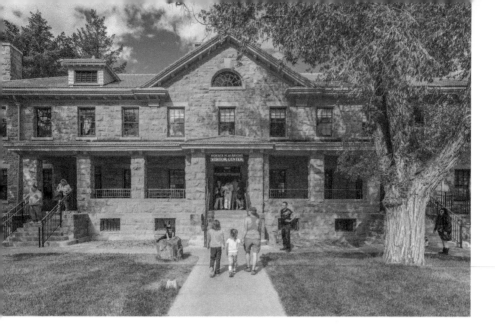

Albright Visitor Center provides information and inspiration for your tour of Mammoth Hot Springs. There are exhibits, WiFi, bathrooms, and a Yellowstone Forever Park Store.

Located at the park's headquarters in Fort Yellowstone, this is the only visitor center in Yellowstone that is open year-round.

The historic structure was built in 1909 by the United States Army as bachelor officers' quarters for the cavalry troops who protected the park before the creation of the National Park Service. Established in 1891, Fort Yellowstone was a U.S. Army fort, and the remaining buildings are used as administrative offices, maintenance facilities and employee residences.

✉ **Addr:**	1 Officers Road, Yellowstone NP WY 82190	♀ **Where:**	44.976315 -110.699893
❓ **What:**	Visitor center	◷ **When:**	Afternoon
👁 **Look:**	East-northeast	↔ **Far:**	25 m (82 feet)

Mammoth Chapel was the last structure built by the army at Fort Yellowstone. Constructed in 1913 with native stone and oak furnishings, the chapel is still used today and is the best preserved building at the fort.

✉ **Addr:**	Grand Loop Road, Yellowstone NP WY 82190	♀ **Where:**	44.972722 -110.697950
❷ **What:**	Chapel	◑ **When:**	Anytime
👁 **Look:**	Northeast	↔ **Far:**	17 m (56 feet)

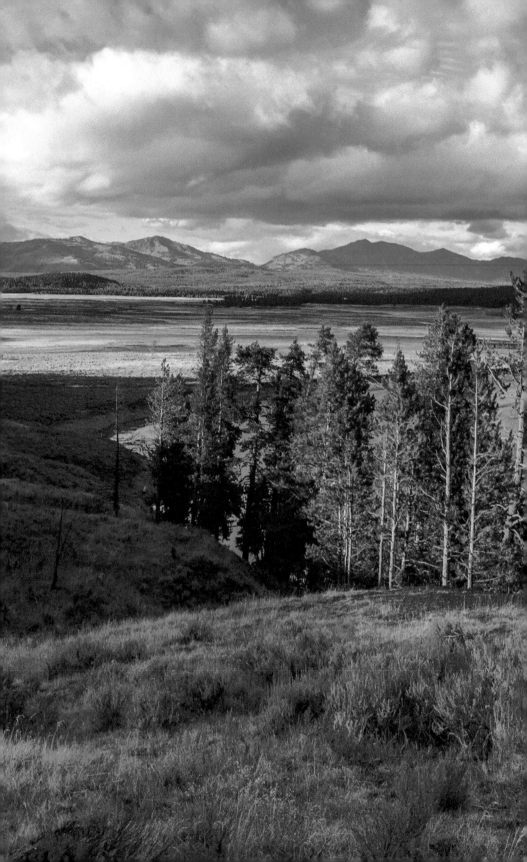

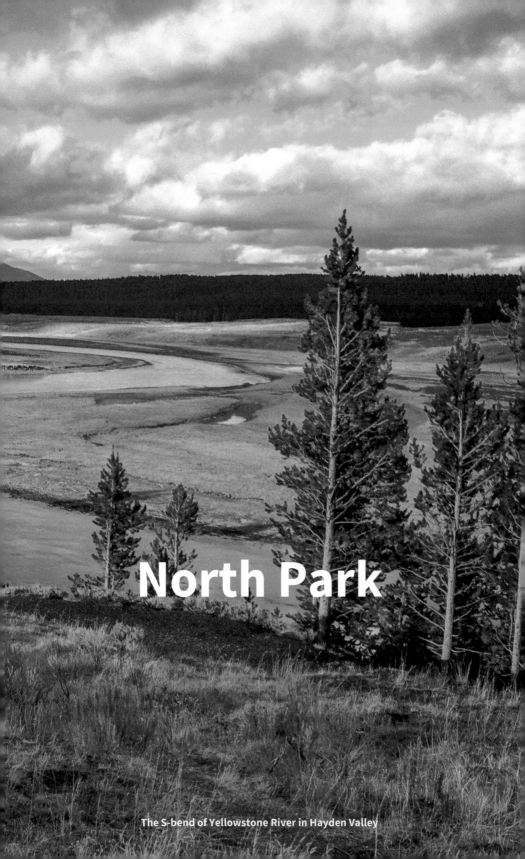

North Park

The S-bend of Yellowstone River in Hayden Valley

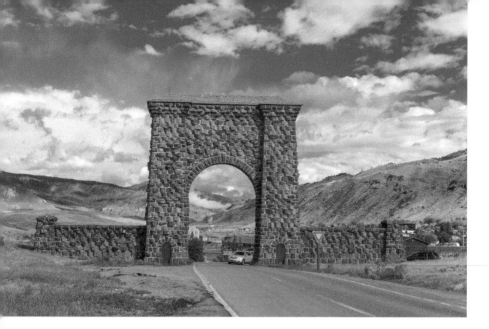

The **Roosevelt Arch** is a rusticated triumphal arch at the north entrance to Yellowstone National Park in Gardiner, Montana. President Theodore Roosevelt laid the cornerstone in 1903, and the top reads "For the Benefit and Enjoyment of the People."

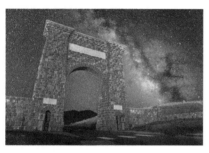
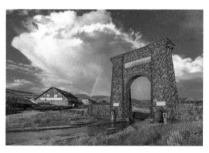

✉ **Addr:**	2819 US-89, Gardiner MT 59030	♀ **Where:**	45.029646 -110.708821
❓ **What:**	Triumphal arch	☾ **When:**	Afternoon
👁 **Look:**	Southeast	W **Wik:**	Roosevelt_Arch

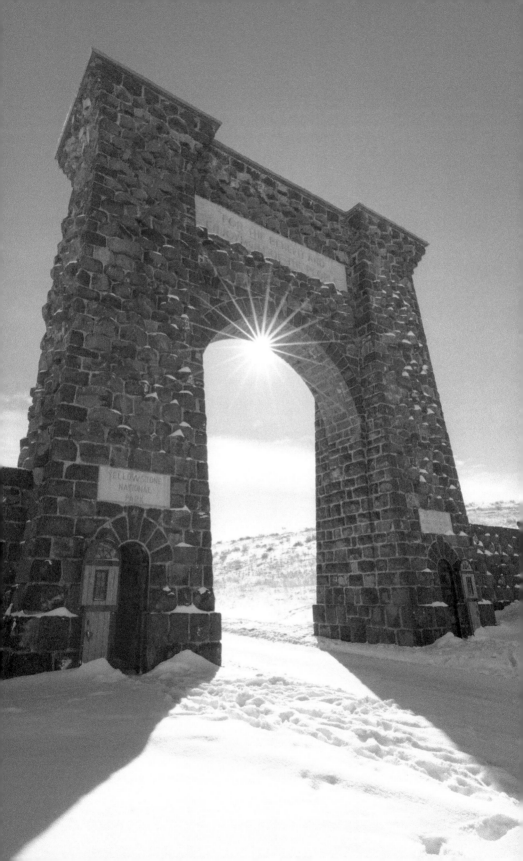

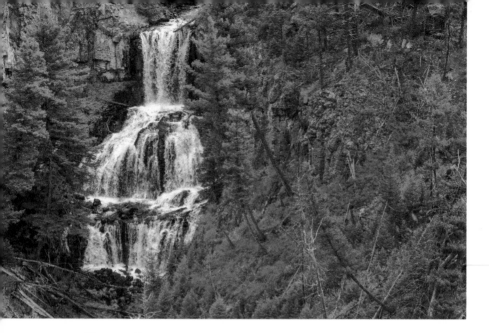

Undine Falls is an easy waterfall to photograph. The 60 foot drop of Lava Creek is located about 4 miles (6.5 km) southeast of Mammoth Hot Springs on Grand Loop Road. A large roadside pullout has an overlook with this view.

The name is pronounced "UN-deen" for female water spirits (in German mythology) that lived around waterfalls.

✉ **Addr:**	Grand Loop Road, Yellowstone NP WY 82190	⚲ **Where:**	44.943717 -110.640344
❷ **What:**	Waterfall	◑ **When:**	Afternoon
👁 **Look:**	East-northeast	↔ **Far:**	150 m (490 feet)

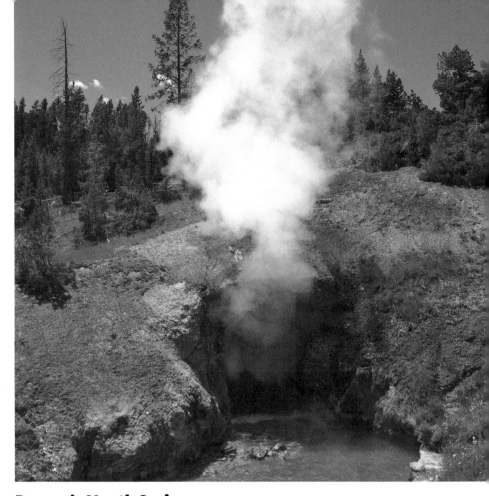

Dragon's Mouth Spring boils out of a deep cave, like smoke billowing from the mouth of a dragon. The boardwalk from the parking lot makes an excellent leading line.

✉ **Addr:**	Mud Volcano Basin, Yellowstone NP WY 82190	♀ **Where:**	44.625173 -110.434771
❓ **What:**	Spring	◑ **When:**	Morning
👁 **Look:**	West	↔ **Far:**	11 m (36 feet)

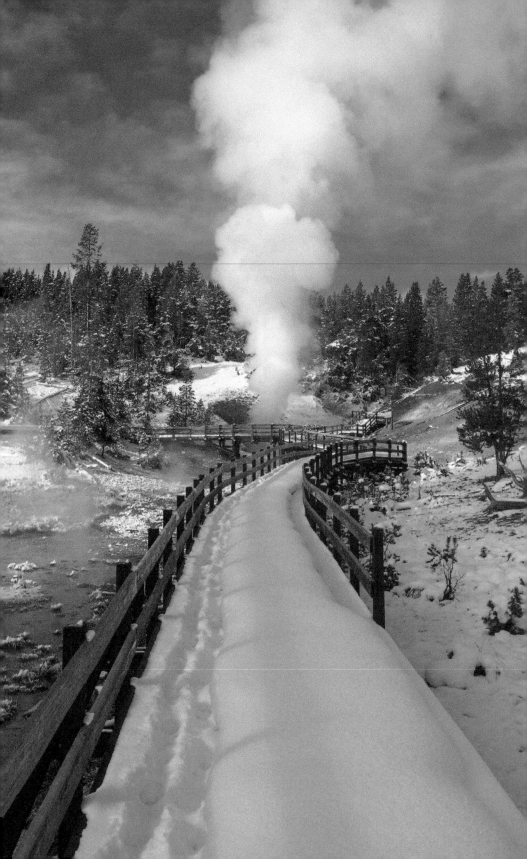

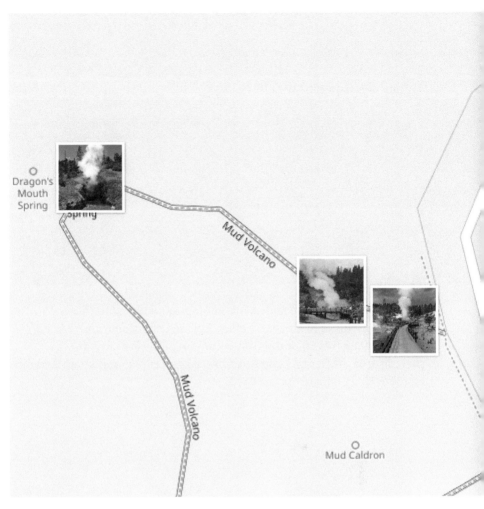

Dragon's
Mouth
Spring

Spring

Mud Volcano

Mud Volcano

Mud Caldron

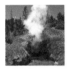

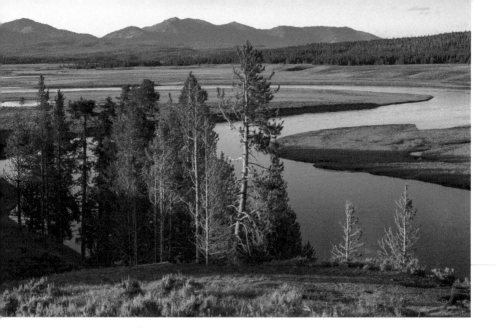

The S is a picturesque and easily-photographed bend in the Yellowstone River in Hayden Valley. Located about four miles (6 km) south (and upstream) of the Grand Canyon of the Yellowstone, a parking area off Grand Loop Road has a 300 feet (80 m) hike up a small knoll for this high viewpoint.

✉ **Addr:**	Hayden Valley, Yellowstone NP WY 82190	♀ **Where:**	44.6679395 -110.4708987	
◑ **When:**	Afternoon	👁 **Look:**	Northeast	
↔ **Far:**	0.73 km (0.45 miles)			

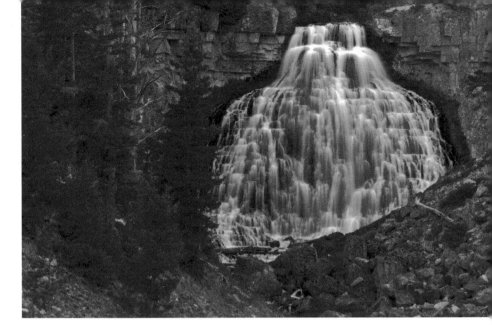

Rustic Falls is a 47-foot-high roadside waterfall that ripples over a basalt cliff. Located about five miles (8 km) south of Mammoth Hot Springs, the waterfall is right next to the road and a small pullout.

With waterfalls, try using a slow shutter speed of around 1/8s to blur the water and create a romantic picture.

✉ **Addr:**	Glen Creek, Yellowstone NP WY 82190	♀ **Where:**	44.9340089 -110.72624
❓ **What:**	Waterfall	◔ **When:**	Afternoon
👁 **Look:**	South-southeast	↔ **Far:**	30 m (100 feet)

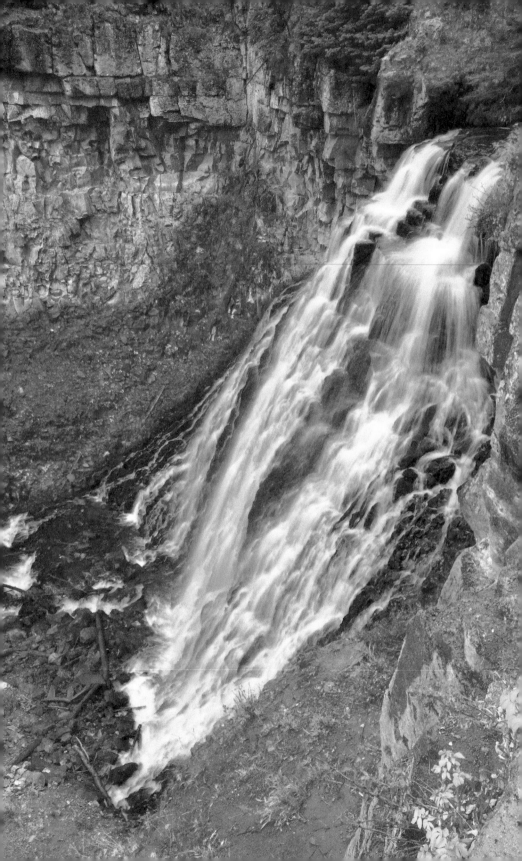

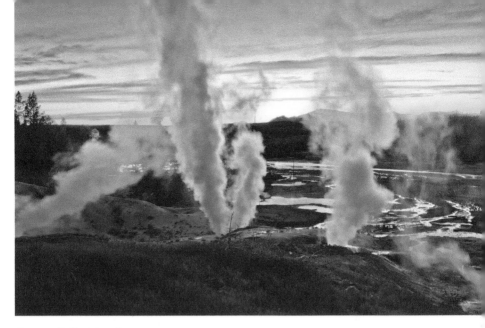

Porcelain Basin is named for the milky color of the mineral deposits. Siliceous sinter is brought to the surface by hot water and forms a "sheet" over this flat area as the water flows across the ground and the mineral settles out.

Porcelain Basin is the north section of Norris Geyser Basin, the hottest geyser basin in the park.

Pictured right are Colloidal Pool and Hurricane Vent, photographed from either side of one spot on the boardwalk.

✉ **Addr:**	Norris Geyser Basin, Yellowstone WY 82190	♀ **Where:**	44.726137 -110.706455	
❓ **What:**	Basin	⏱ **When:**	Anytime	
👁 **Look:**	East	W **Wik:**	Geothermal_areas_of_Yellowstone#Norris_Geyser_Basin	

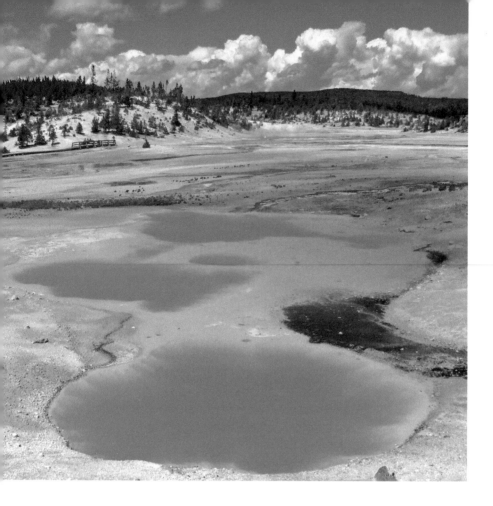

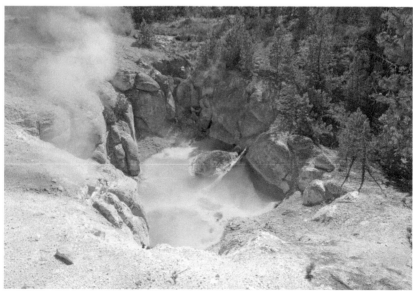

Crown
Jewels
Spring

Primrose
Lava Pool Springs

Swiss Cheese
Pool

Whale
Mouth

Scummy
Pool

Crackling
Lake

Crackling
Spring

Lewis Mud
Pots

Jetsam
Pool
Palm Pool

Milky Complex

Teal Blue
Bubbles

Norris
Geyser
Basin

Bathtub
Spring

Steamvalve
Spring

Emerald
Spring

Dr. Allen's
Paintpot

Branch
Spring

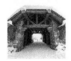

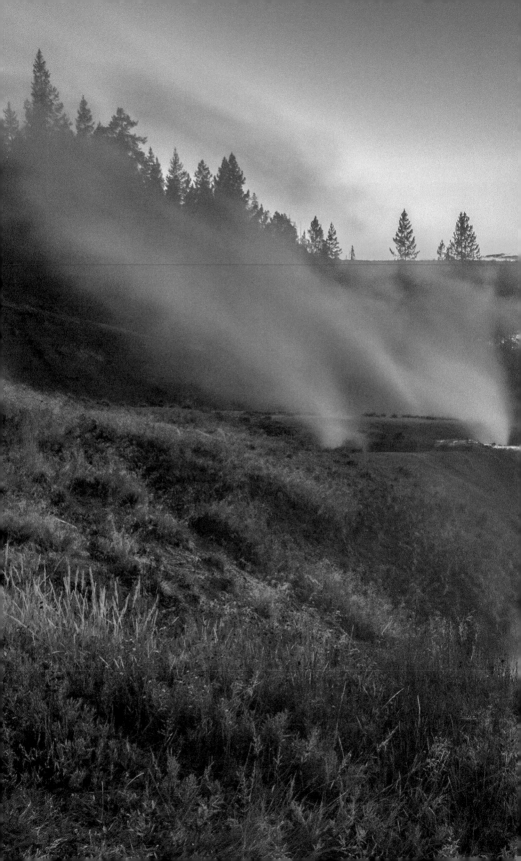

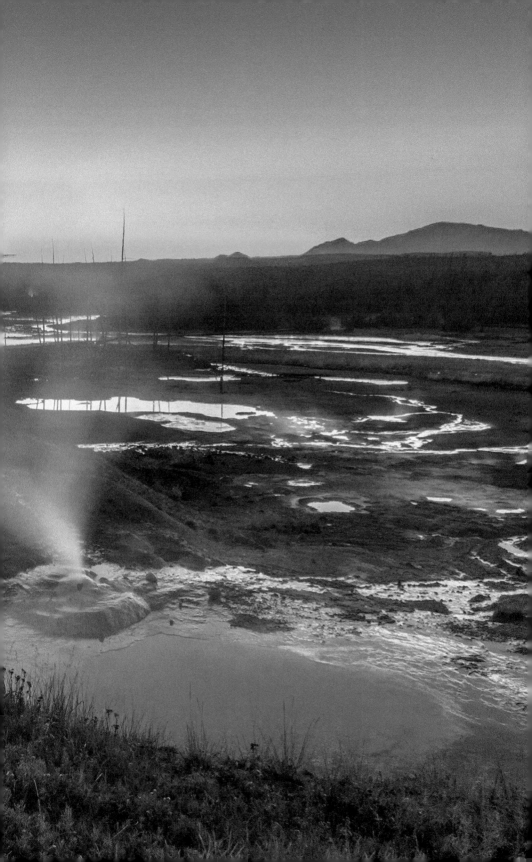

Steamboat Geyser is the world's tallest currently-active geyser, reaching over 300 feet (91 m) high. However, the intervals between major eruptions range from three days to fifty years, so it can be difficult to photograph. Fortunately, the National Park Service maintains current information at a dedicated webpage, nps.gov/yell/learn/nature/steamboat-geyser.htm.

Notice that all three pictures here include human interest for scale and depth.

✉ **Addr:**	Norris Geyser Basin, Yellowstone NP WY 82190	♥ **Where:**	44.723404 -110.703442	
❓ **What:**	Geyser	◑ **When:**	Anytime	
👁 **Look:**	North-northeast	W **Wik:**	Steamboat_Geyser	

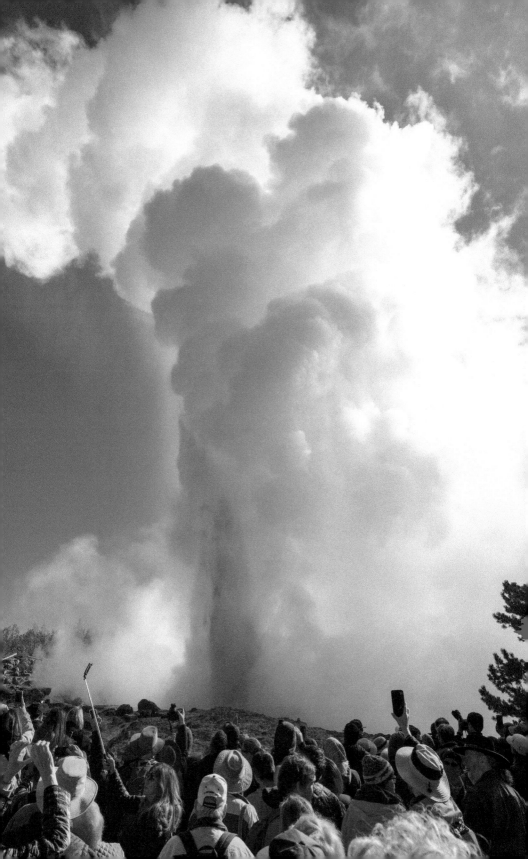

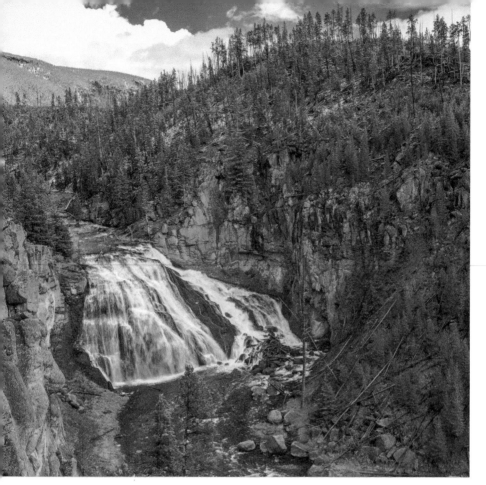

Gibbon Falls is another roadside waterfall, halfway between Old Faithful and Mammoth Hot Springs. A paved viewing area by a parking lot has a splendid view. The waterfall faces south with a cliff on the east side, so midday or early afternoon light is best.

✉ **Addr:**	Grand Loop Rd, Yellowstone NP WY 82190	♀ **Where:**	44.653799 -110.771558
❷ **What:**	Waterfall	◑ **When:**	Afternoon
👁 **Look:**	East-northeast	W **Wik:**	Gibbon_Falls

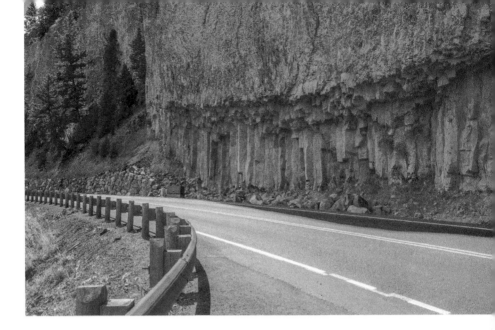

Overhanging Cliff is a cliff of vertical basalt columns that overhangs the Grand Loop Road, north of the Grand Canyon, by Devil's Den and Tower Fall.

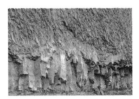

✉ **Addr:**	Grand Loop Rd, Yellowstone NP WY 82190	♀ **Where:**	44.897558 -110.389362
❷ **What:**	Basalt columns	☽ **When:**	Morning
👁 **Look:**	South	W **Wik:**	Overhanging_Cliff

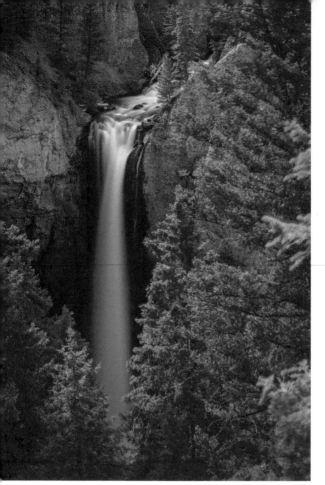

Tower Fall drops 132 feet (40 m) and is named for rock pinnacles at the top of the fall. Located north of the Grand Canyon near Devil's Den, the waterfall is an easy walk from Tower General Store off Grand Loop Road.

✉ **Addr:**	Grand Loop Road, Yellowstone NP WY 82190	♀ **Where:**	44.89323 -110.385674
❷ **What:**	Waterfall	◑ **When:**	Morning
👁 **Look:**	West-northwest	W **Wik:**	Tower_Fall

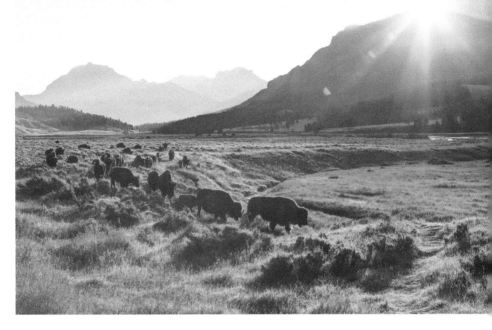

Lamar Valley is the best area in Yellowstone to photograph wildlife. The area along the Lamar River — a 40-mile-long (64 km) tributary of the Yellowstone River — is often referred to as America's Serengeti, being abundant with bears, wolves, elk and bison.

Located in the northeastern corner of the park, the valley can be photographed from the NE Entrance Road (U.S. 212), between Tower Junction and the Northeast Entrance Station.

Particularly in the hot summer months, the animals are most active at dawn, so plan ahead and be in the valley before sunrise. As with people, the best pictures are from nose height. Focus on the animal's nearest eye, as that will be the focus of your viewer's eye.

This completes our photo tour of Yellowstone National Park.

✉ **Addr:**	Lamar Valley, Yellowstone NP WY 82190	♀ **Where:**	44.8707889 -110.2007246
❷ **What:**	Viewpoint	◑ **When:**	Afternoon
👁 **Look:**	South-southeast	↔ **Far:**	4.52 km (2.81 miles)

Credits

Thank you to the many wonderful people and companies that made their work available to use in this guide.

Photo key: The number is the page number. The letters reference the position on the page, the distributor and the license. Key: a:CC-BY-SA; b:bottom; c:center; d:CC-BY-ND; e:CC-PD; f:Flickr; h:Shutterstock standard license; s:Shutterstock; t:top; w:Wikipedia; y:CC-BY.

Cover image by Lynn Yeh/Shutterstock. Back cover image by CSNafzger/Shutterstock. Other images by: Elizabeth Abalo (79 wa); Acroterion (37t sh); Matthew Thomas Allen (71t sh); Mh Anderson Photography (31t sh); Galyna Andrushko (108t sh); Berzina (64t fd); Bhme Photography (84t sh); Borisvetshev (43b sh); Busara (65 fy); Limarie Cabrera (117b fy); Michelle Callahan (71 sh); Castle_nature_studio (83t sh); Danica Chang (130t sh); Chase Clausen (85 sh); Stephen A Crane (51 sh); Steve Cukrov (111, 131t sh); Dancestrokes (112 sh); Jim David (51b sh); Sharon Day (71 fa); Dconvertini (145t sh); Emattil (44 sh); Eqroy (32t, 33, 35, 35b sh); Inger Eriksen (106t sh); Evenfh (103 sh); F11photo (29, 36t, 128t sh); Julius Fekete (114 sh); Frank Fichtmueller (148 sh); Pascal Franck (106 sh); Frankhh (31 sh); Filip Fuxa (62t sh); Gagliardiphotography (80t sh); Christopher Gardiner (135 sh); Gj-nyc (49, 120t sh); Natali Glado (81 sh); Gracious_tiger (75 fa); Don Graham (138t sh); Haveseen (60t, 60 sh); Eastvillage Images (56t, 63 wa); Brocken Inaglory (76t, 96t sh); Irinak (57 sh); Andrea Izzotti (149t sh); Janaph (52 sh); Patrick Jennings (91, 97 fy); James St. John (72t, 73, 76, 84, 145 sh); Michael Andrew Just (53 sh); Alexey Kamenskiy (83b sh); Kenneth Keifer (104, 125t fy); Micah Kipple (61t sh); Oleksandr Koretskyi (46 sh); Dmitry Kovba (31 sh); Jess Kraft (76 sh); Marieke Kramer (38t sh); Languste (123 sh); Leochen66 (101 sh); Thomas Levine (39 sh); Lucky-photographer (114 sh); Margaret.w (114t sh); James Mattil (122t sh); Mia2you (67t sh); Mj - Tim Photography (58t sh); Mlorenz (68t wa); Mminc10 (40 sh); Nagel Photography (35t, 59t, 107 sh); Newtonian (55 fa); Oddharmonic (85t sh); Mendenhall Olga (44, 49, 51t, 117t sh); Tom Olson (134t sh); Oomka (126 fe); Yellowstone National Park (35, 36, 40t, 40, 41, 43t, 46t, 78t, 86, 93t, 93, 93, 94, 96, 98, 100, 102, 110t, 111t, 115, 117c, 118, 120, 121, 124t, 125, 128, 128, 129, 132, 140c, 142t, 142, 143, 147t, 149b, 150b sh); National Parked (144t sh); Pixeljoy (75 sh); Susanne Pommer (28t sh); Raksybh (131 sh); Tom Reichner (150t sh); Anders Riishede (67c sh); Poul Riishede (26, 49t, 52t sh); Robynrg (31b sh); Rodclementphotography (98t sh); Roopankit (135t sh); Jason Patrick Ross (118, 136 sh); Benjamin Schaefer (46 sh); Sdclicks (54t sh); Fedor Selivanov (51, 138b sh); Stephen Strum (90t sh); Max Studio (102t sh); Sunguard (44t wa); Supercarwaar (92t sh); Brett Taylor Photography (71b fy); Bernd Thaller (118t sh); Tokelau (58 fa); Bryan Ungard (99 sh); Vagabond54 (54 sh); Abbie Warnock-matthews (47, 88, 100t, 109 sh); Kath Watson (146t wa); Wikibunny11 (57t sh); Kris Wiktor (67b, 86t, 87, 137t, 140 fy); Charles Willgren (110 fa); Eddie Yip (69 sh); Zhiqin Zhu (62 sh).

Some text adapted from Wikipedia and its contributors, used and modified under Creative Commons Attribution-ShareAlike (CC-BY-SA) license. Map data from OpenStreetMap and its contributors, used under the Open Data Commons Open Database License (ODbL).

For corrections and improvements, thank you to Gustav Verderber, Joseph Lange.

This book would not exist without the love and contribution of my wonderful wife, Jennie. Thank you for all your ideas, support and sacrifice to make this a reality. Hello to our terrific kids, Redford and Roxy.

Thanks to the many people who have helped PhotoSecrets along the way, including: Bob Krist, who answered a cold call and wrote the perfect foreword before, with his wife Peggy, becoming good friends; Barry Kohn, my tax accountant; SM Jang and Jay Koo at Doosan, my first printer; Greg Lee at Imago, printer of my coffe-table books; contributors to PHP, WordPress and Stack Exchange; mentors at SCORE San Diego; Janara Bahramzi at USE Credit Union; my bruver Pat and his family Emily, Logan, Jake and Cerys in St. Austell, Cornwall; family and friends in Redditch, Cornwall, Oxford, Bristol, Coventry, Manchester, London, Philadelphia and San Diego.

Thanks to everyone at distributor National Book Network (NBN) for always being enthusiastic, encouraging and professional, including: Jed Lyons, Jason Brockwell, Kalen Landow (marketing guru), Spencer Gale (sales king), Vicki Funk, Karen Mattscheck, Kathy Stine, Mary Lou Black, Omuni Barnes, Ed Lyons, Sheila Burnett, Max Phelps, Jeremy Ghoslin, Les Petriw and Claire D'Ecsery. A special remembrance thanks to Miriam Bass who took the time to visit and sign me to NBN mainly on belief.

The biggest credit goes to you, the reader. Thank you for (hopefully) buying this book and allowing me to do this fun work. I hope you take lots of great photos!

© Copyright

PhotoSecrets Yellowstone National Park, first published October 1, 2019. This version output September 5, 2019.

ISBN: 9781930495371. Distributed by National Book Network. To order, call 800-462-6420 or email customercare@nbnbooks.com.

Curated, designed, coded and published by Andrew Hudson. Copyright © 2019 Andrew Hudson/PhotoSecrets, Inc. Copyrights for the photos, maps and text are listed in the credits section. PHOTOSECRETS and the camera-map-marker icon are registered trademarks of PhotoSecrets.

"'And what is the use of a book,' thought Alice
'without pictures or conversations?'"
— Alice's Adventures in Wonderland, Lewis Carroll

© Copyright

🔨 Disclaimer

The information provided within this book is for general informational purposes only. Some information may be inadvertently incorrect, or may be incorrect in the source material, or may have changed since publication, this includes GPS coordinates, addresses, descriptions and photo credits. Use with caution. Do not photograph from roads or other dangerous places or when trespassing, even if GPS coordinates and/or maps indicate so; beware of moving vehicles; obey laws. There are no representations about the completeness or accuracy of any information contained herein. Any use of this book is at your own risk. Enjoy!

✉ Contact

For corrections, please send an email to andrew@photosecrets.com. Instagram: photosecretsguides; Web: www.photosecrets.com

∎∎ Index

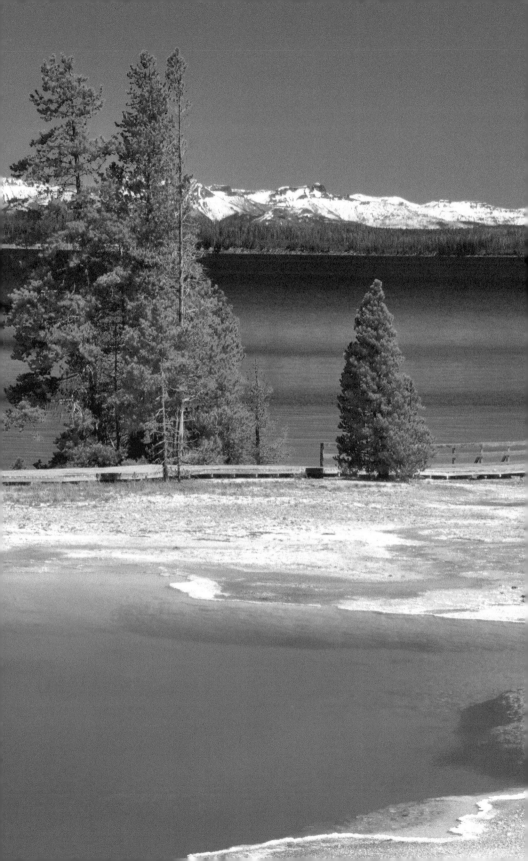

Detail of the Grand Prismatic Spring

👍 More guides from PhotoSecrets